POSTCARD HISTORY SERIES

Lake
Arrowhead

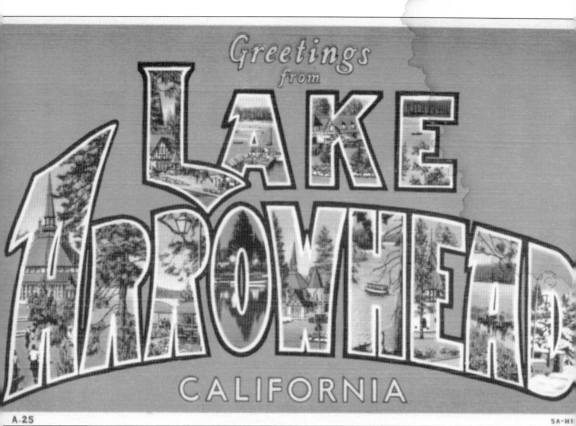

"GREETINGS." We hope you enjoy this postcard tour of Lake Arrowhead. (CC.)

FRONT COVER: In 1927, the Clubhouse was renamed the North Shore Tavern. This highly posed *c.* 1932 view screams that this is the place where the "leisure class" comes to relax and play. With wide green lawns, first-rate dining (and Prohibition drinking), guest cottages, a large dock with ferry service, and a pocket beach, the tavern was an instant landmark. Today it is the UCLA Conference Center. (FI.)

BACK COVER: The Lake Arrowhead Orchestra was really more of a group of collegiate friends who played nightly in the dance pavilion in the summer. The goal was to attract a younger crowd, and to this end the orchestra was successful. With striped jackets and hair parted down the middle, these young men strike a dramatic pose. (NC.)

POSTCARD HISTORY SERIES

Lake Arrowhead

Roger G. Hatheway and Russell L. Keller

ARCADIA
PUBLISHING

Copyright © 2006 by Roger G. Hatheway and Russell L. Keller
ISBN 0-7385-4702-6
Published by Arcadia Publishing
Charleston SC, Chicago IL, Portsmouth NH, San Francisco CA

Printed in the United States of America

Library of Congress Catalog Card Number: 2006933247

For all general information contact Arcadia Publishing at:
Telephone 843-853-2070
Fax 843-853-0044
E-mail sales@arcadiapublishing.com
For customer service and orders:
Toll-Free 1-888-313-2665

Visit us on the Internet at www.arcadiapublishing.com

CONTENTS

Acknowledgments

It has been a privilege and an honor to have been selected by Arcadia Publishing to write a second book for them. This experience has only been enhanced by the offer of my good friend and fellow historian Roger Hatheway to join with me in authoring this book. His immense knowledge of the history of this area should become obvious to all, as you enjoy our collaborative effort. The book has also given me the opportunity to share with you, the reader, rare and wonderful postcard images that I have collected over many years. I wish to also thank the following individuals who have contributed to my knowledge of this beautiful area: Voni Saxbury, Pat Huskey, Clark Hahne, John Robinson, Pauliena LaFuze, Cheryl Santello, Stan Bellamy, Chuck McCluer, and my wife, Carol.

—*Russ Keller*

I should first like to thank my dear friend and historical enthusiast Russ Keller. He is as certifiable a collector as I am. I should also like to thank all of my mountain friends, historical-society boosters, and past readers of my newspaper columns. On behalf of both me and my father, a very special thank you goes out to my great-great-aunt Henrietta Bliss Hatheway. This remarkable woman, a teacher, helped to fund both of our educations. I carry her gift with me every day. Finally, I thank Lora, my wife, my best friend, and the only reason I ever finish anything important at all.

—*Roger Hatheway*

Finally, we both wish to thank the original publishers of all of the postcards contained in this book. With rare exception all are out of business. Their legacy shall, however, withstand the test of time.

INTRODUCTION

This book contains "golden nuggets" of treasure. Postcards are true windows into the past. Their images vary from one-of-a-kind to those that were printed by the tens of thousands, and the message on the front or back of the card often provides poignant insight relative to the image, the time, or the place. The rarest of all are postcards with images and text so highly evocative that they can make one laugh or cry. These are the cards that true collectors, or "prospectors," of postcards spend countless hours searching for, and are one of the reasons that collecting postcards is one of the fastest-growing hobbies in America.

This postcard history of Lake Arrowhead contains many never-before-published images from the single largest and most diverse collection of San Bernardino Mountain ephemera ever assembled. From the late 1890s to the end of the 1960s, the following images and text provide personal insight into the essence of Lake Arrowhead. The printed back of one postcard sent in 1928 reads, "Only 84 Miles from Los Angeles. Lake Arrowhead in Arrowhead Woods offers the utmost in recreational advantages—here swimming, dancing, hiking, golfing, boating, fishing, tennis, horse-back riding, and scenic motor drives enchant the lover of the open places." This is pretty powerful stuff, and it was clearly written to attract the young and the old, and the rich and the poor—offering something that just about anyone could enjoy.

During the "golden years," from the early 1920s to the end of the 1950s, Lake Arrowhead truly had it all. In this book, the history of Lake Arrowhead is laid bare by including not only the postcard image itself, but by quoting often from the handwritten text on the card to provide an evocative and human history of this historic alpine community. Here the past comes miraculously alive by spotlighting the gem-like qualities that are a part of the history of this very special place.

The first Lake Arrowhead–associated postcards were sent at the end of the 19th century. They generally depict the Arrowhead Hot Springs Hotel with various versions of the natural geological landmark "arrowhead" blaze above. Beginning around 1900, postcards of the Squirrel Inn, a private resort, were printed for the use of club members. The Squirrel Inn was the brainchild of James Mooney, the eccentric capitalist behind the Arrowhead Reservoir Company, the builders of a reservoir first known as Little Bear Lake and then as Lake Arrowhead. In a nutshell, without the efforts of James Mooney, Lake Arrowhead would simply not exist.

From 1900 to the early 1920s, Little Bear Lake was depicted in a wide variety of postcard types, including real photo, white border, and hand tinted. From the late 1920s to the 1950s, highly colorful linen cards, real-photo images, and white-border cards recorded every aspect of life at Lake Arrowhead. Modern glossy or chrome cards documented the last of the golden years at Lake Arrowhead.

All of the postcards depicted within this book are amazing survivors. Put into shoeboxes, drawers, family albums, and scrapbooks after having been received, they were frequently overlooked when the time came to preserve family correspondence. Why should one keep a postcard when the image was freely sold and the message written so that everyone could see? They really do survive as "golden nuggets." In this unique and informative collaboration, authors Roger G. Hatheway and Russell L. Keller highlight all that is magical about Lake Arrowhead. Postcards were originally purchased and sent for pennies. Here they are invaluable tools used by the authors to illustrate the history and romance of Lake Arrowhead.

IMAGE CREDITS

All images contained herein are from Russell L. Keller's private collection of San Bernardino Mountain ephemera. Many of the images are one-of-a-kind real-photo cards or other printed cards with no recorded publisher. Those published by companies or business enterprises, and cards with registered trademarks or with indications of copyright are credited at the end of each caption. The following abbreviations appear at the end of each caption to reference individual publishers: Curteich-Chicago "C.T. Art-Colortone" (CC); B. R. Montgomery, Riverside, California (BRM); Rosecraft, Crestline-Inyokern, California (R); Putnam Studios, Los Angeles (PS); Western Resort Publications (Ferris Scott), Santa Ana, California (WRP); Rim O'World Guide, Santa Ana (ROW); Driftwood Company (DC); James J. Gillick and Company, Berkeley, California (JGC); Dexter Press, Inc., West Nyack, New York (DPI); Royal Pictures, Colton, California (RP); Union Oil Company of California (UOC); Mike Roberts Color Production, Oakland, California (MRC); Frashers, Inc., Pomona, Califonia (FI); Van Ornum Colorprint Company, Los Angeles (VOC); Edw. H. Mitchell, San Francisco (EHM); The Bear Valley Photographer, Wright M. Pierce (BVP); C. T. Photochrom (CTP); Julius J. Hecht, Los Angeles (JJH); The Flag Studio, Pasadena, California (TFS); Western Publishing and Novelty Company, Los Angeles (WPN); Aerograph Company (AC); Dr. J. N. Baylis, San Bernardino, California (JNB); M. D. Thiebaud, San Bernardino (MDT); Newman Post Card Company, San Francisco (NPC); Jones-Photo, San Bernardino (JP); Neuner Corporation, Los Angeles (NC); C. T. American Art (CTA); Colourpicture, Boston (C); Color Krome, Mellinger (CK); Fraternal Suppliers, Palmdale, California (FS); Wayside Press, Los Angeles (WP); Sid Harper, Big Bear Lake, California (SH); and The Albertype Company, Brooklyn, New York (TAC).

One

THE ROAD TO
LAKE ARROWHEAD

Lake Arrowhead would not exist without a good road leading to it. This chapter highlights the development of the road to Lake Arrowhead, as well as the prominent features and landmarks along the way.

Native American trails crisscrossed the mountains, but it was not until 1852 that the first "road" to the crest was built by Mormon settlers from San Bernardino. Known as the "Mormon Road," it was really a widened trail and was used sporadically from the 1850s to the 1880s.

In the early 1890s, the Arrowhead Reservoir Company came up with the idea of creating a huge mountain-water system to irrigate the San Bernardino Valley. The company began building a genuine road to the crest in the summer of 1891 and completed construction early in 1892. A tollhouse at the upper and lower ends of the roadway greeted surprised travelers. Lawsuits were brought over high rates, but the company had immense influence, and it was not until 1905 that the toll road became a free county road.

By 1909, due largely to the efforts of Dr. J. N. Baylis of Pinecrest, the free county road was opened as a public highway for the use of motorized vehicles. Prior to this, only horse-drawn vehicles were allowed without special permit. Ultimately, the efforts by Baylis and others resulted in the establishment of the scenic 101-mile "Rim of the World Drive." Dedicated in July 1915, the route was soon widely recognized for its natural beauty.

By the mid-1920s, highway engineers realized that the original 1915 Rim of the World Drive alignment was inadequate. On a holiday weekend, it could take hours to reach the crest. A "High Gear" road was soon planned, allowing the driver of a standard automobile to travel from San Bernardino to the mountaintop entirely in high gear. Construction began in the late 1920s, but it was not until the mid-1930s that the roadway was essentially completed. Roadway improvements continued, and by the late 1960s, the present four-lane route was completed.

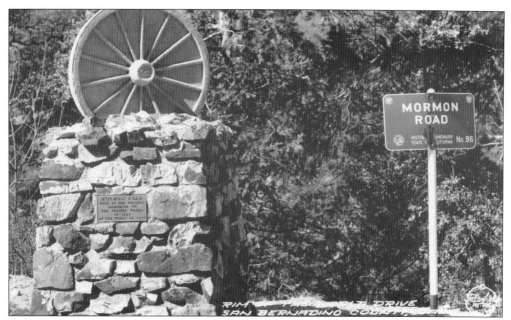

THE MORMON ROAD. In 1852, Mormon colonists of San Bernardino completed a "roadway" to the mountains in search of lumber. It was really a widened trail that ran adjacent to streambeds, through ravines and gullies, and up steep hillsides. Generally referred to by historians as the Mormon Road, it is listed as California Historical Landmark No. 96. (FI.)

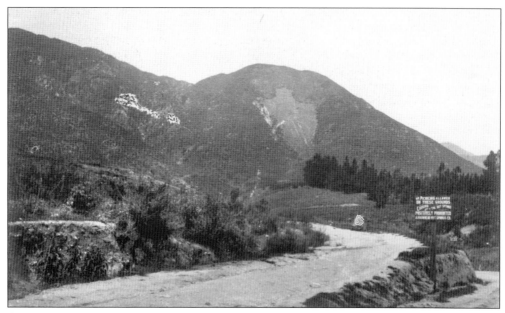

ARROWHEAD AT BEGINNING OF ROAD. Since 1852, the arrowhead has greeted mountain-bound road travelers. This postcard shows the road to the Arrowhead Springs Hotel as it splits off from the original Rim of the World Drive, which continues up Waterman Canyon. The sign reads, "No picnicking allowed on these grounds. Cooking in the hot springs positively prohibited. Arrowhead Hot Springs Company."

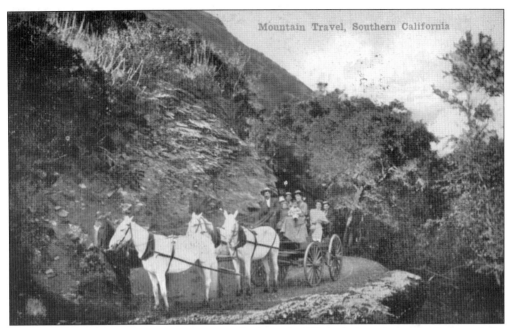

ARROWHEAD TOLL ROAD WAGONS. To facilitate building their main reservoir (now Lake Arrowhead), the Arrowhead Reservoir Company constructed a toll road up the mountain, completing construction in the spring of 1892. The public complained about the cost, but it was not until 1905 that the Arrowhead Reservoir Toll Road became a free county road leading to the crest by way of Waterman Canyon. (VOC.)

FREE COUNTY ROAD. The back of the card relates that this is "a picture of Sarah & Ralph taken up in the Mts. on the Squirrel Inn road." Dated November 21, 1910, this is one of the earliest photograph postcards of travel along the free county road (established in 1905) to the San Bernardino Mountain resorts.

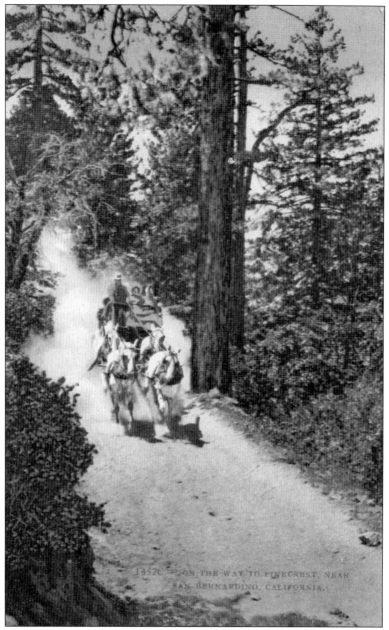

A True Mountain "Stagecoach." The front of this card reads, "On the way to Pinecrest, near San Bernardino, California." In 1906, Dr. John N. Baylis, a San Bernardino physician who had purchased a mountain retreat, began construction of his Pinecrest mountain resort. This postcard must have been published soon thereafter. It shows a genuine "stage," complete with horses and a driver, as seen throughout the historic American West. Scheduled stage service to locations in the San Bernardino Mountains, from Big Bear to Lytle Creek, was commonplace. This is, however, the only known postcard view of a traditional "stagecoach" in the San Bernardino Mountains. All other published views depict various versions of the popular mountain "auto stage," really a motorized truck with seats used to deliver passengers to all mountain resorts and other destination points from about 1910 to the mid-1920s. (EHM.)

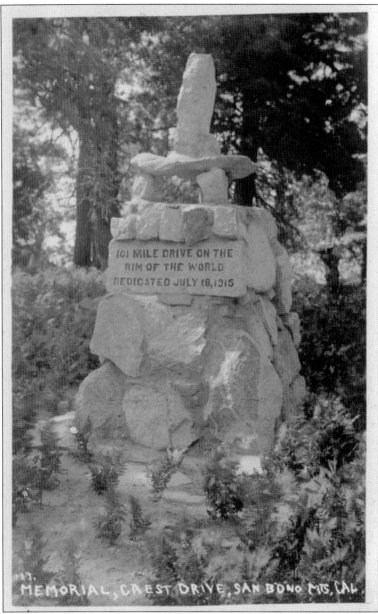

101 MILE DRIVE ON THE
RIM OF THE WORLD
DEDICATED JULY 18,1915

MEMORIAL, CREST DRIVE, SAN BDNo MTS, CAL.

RIM DRIVE DEDICATION MONUMENT. Remarkably, the original Rim Drive dedication monument, although moved from its original location, is still standing. It is located on the south side of Highway 18 between Rimforest and Baylis Park. The original name of the "101 Mile Drive on the Rim of the World, Dedicated July 18, 1915" was actually Crest Drive. Vandals have knocked the top off of the original landmark, and the condition of the marker today is decidedly precarious. A 1915 promotional brochure describes the route as passing "through many a mountain mile of scenic grandeur, through stately pines, by ever snow-capped peaks, along rushing brooks and past mirror lakes, it leads into Bear Valley and on down majestic Santa Ana Canyon to San Bernardino again." When first opened, the Rim of the World Drive was touted as being the longest automobile road in the country with roadway sections at such high elevations as 7,000 to 8,000 feet. (BVP.)

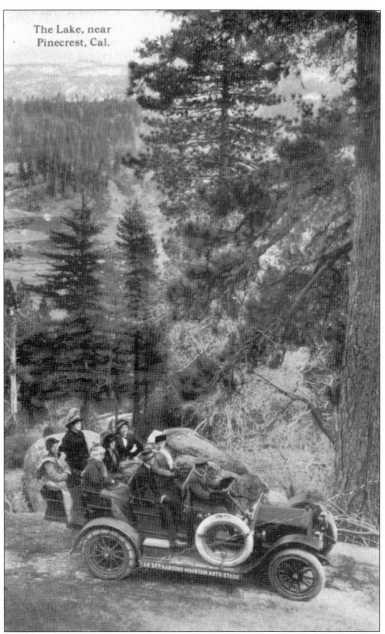

The Lake, near
Pinecrest, Cal.

SAN BERNARDINO MOUNTAIN AUTO STAGE. By about 1915, "auto stages" (trucks with passenger seats bolted onto the chassis) had replaced horse-drawn stages and offered daily service to the mountains over the newly opened Rim of the World Drive. In 1915, the Green brothers—having taken over the earlier San Bernardino Auto Stage Company, which was founded in 1912 by Kirk Phillips—organized the Mountain Auto Line. The term "stage" was used interchangeably with "bus" until at least the mid-1940s. A 1925 guidebook notes, "*The Motor Transit Co.* during the season runs a daily special from Los Angeles at 7 a.m., and from San Bernardino at 10 a.m., reaching Pinecrest at 12 and Arrowhead Lake at 12:45 p.m. There is daily local service between Arrowhead Lake and Big Bear Lake in 3 hrs.; also between Big Bear Lake and Redlands, via Mill Creek in 5 hrs. 20 min." (CTP.)

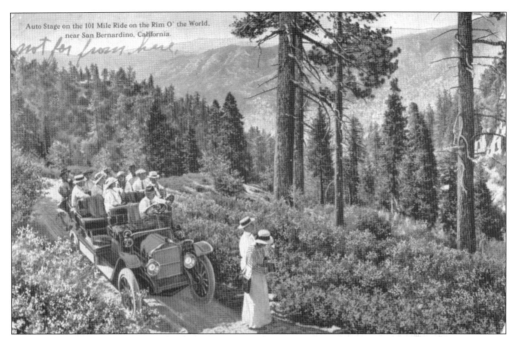

AUTO STAGE ON THE RIM. This postcard depicts a San Bernardino Mountain auto stage as operated by Max and Perry Green en route to the crest "on the 101 Mile Rim O' the World Drive near San Bernardino, California." This postcard appears in almost every modern publication on the history of the San Bernardino Mountains. (JJH.)

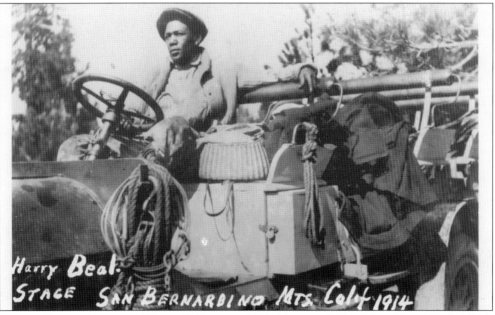

HARRY BEAL—PIONEER "STAGE" DRIVER. This view spotlights driver Harry Beal and his "stage" in the San Bernardino Mountains in 1914. Attached to the vehicle are a fishing creel for recreation and a large block and tackle (like a winch) for emergencies. Beal, an African American, was a driver for the first mountain auto-stage line. Before this, he had been a private chauffeur for a prominent family in Redlands.

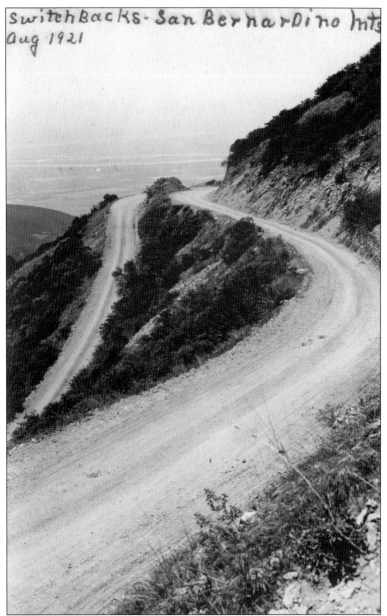

Switchbacks - San Bernardino Mts. Aug 1921

THE DREADED SWITCHBACKS. Near Panorama Point, the grade of the original Rim of the World roadway alignment became very steep, requiring the use of switchbacks whereby the road cut back and forth in a series of ever-ascending loops. The switchbacks were originally built to accommodate the physical limits of horses and mules, and they were already in place when the automobile first appeared on the scene about 1915. Incredibly, many early automobiles had an even more difficult time in climbing the steepest grades than did wagons drawn by animals. They did, in fact, present a considerable challenge to automobile engineering. As a result, the switchbacks were frequently used to field test new cars and trucks from about 1915 into the 1920s. Teenage drivers tested themselves at every turn, and all mountain residents must have breathed a collective sigh of relief when the worst of the switchbacks were eliminated by construction of the High Gear Road.

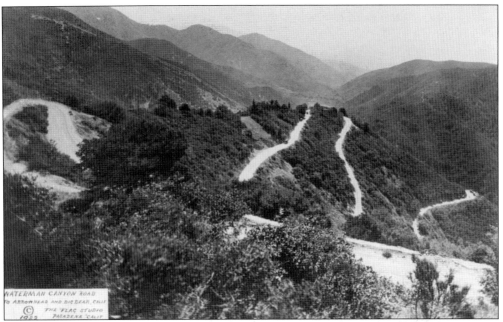

WATERMAN CANYON ROAD. This 1922 view shows the switchbacks with the San Bernardino Valley as a backdrop. However dangerous and time consuming the switchbacks may have been, they did provide incredible scenic vistas at literally every turn. (TFS.)

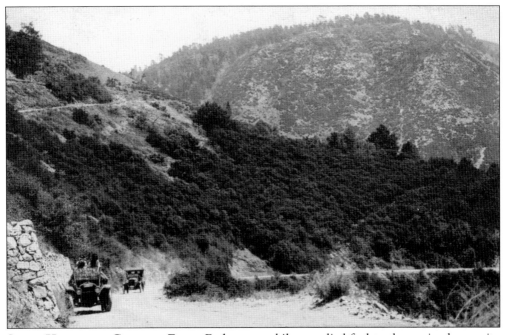

STEEP HILLS AND GRAVITY FEED. Early automobiles supplied fuel to the engine by gravity feed and not by a fuel pump. This caused problems on steep grades like the switchbacks, and many automobiles had to back up steep hills in order to keep the engine running. This *c.* 1917 view shows an auto stage and an automobile on the way up the hill.

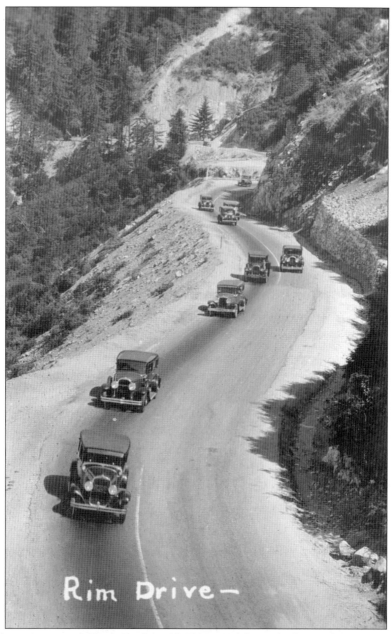

Rim Drive—

HEAVY TRAFFIC ON THE RIM. By the mid-1920s, California highway planners and engineers realized that the west-end capacity of the now famous Rim of the World Drive had exceeded all expectations. On big holiday weekends, one could spend well over four hours on the way from San Bernardino to the crest. In 1923, the previous Fourth of July record of 800 cars more than doubled, with 2,000 cars going up Waterman Canyon alone, and, by 1926, it was estimated that 6,000 cars made the same trip. Traffic was a mess, with long lines extending up the narrow, steep, two-lane road well past midnight, and extensive roadway improvements were planned. The centerpiece of these improvements was the construction of a High Gear Road. From the late 1920s to the mid-1930s, the new road was built in segments to alleviate congestion. This view shows the newly completed High Gear Road. Traffic appears heavy but manageable.

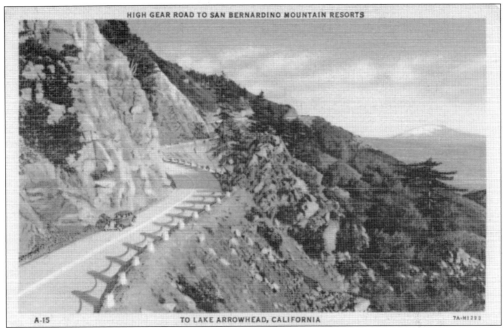

A-15 TO LAKE ARROWHEAD, CALIFORNIA 7A-H1283

THE HIGH-GEAR ROAD. The construction of the High Gear Road was a true milestone for mountain residents and visitors alike. The switchbacks were eliminated, and what had been a grueling holiday adventure became an ordinary drive. The mountains were accessible to all for the first time. The back of the card above reads, "The Road to San Bernardino Mountain Resorts: This glorious scenic drive over the high-gear state highway leads to the beautiful land of sky-blue waters in the San Bernardino Mountains, the famed vacation spot above the clouds." The card below, taken immediately after construction of the roadway and before construction of the rock posts and chain-link guardrails, clearly shows just how difficult the construction was (the road was literally carved into the mountainside) and how precipitous the drive was. (Above CC.)

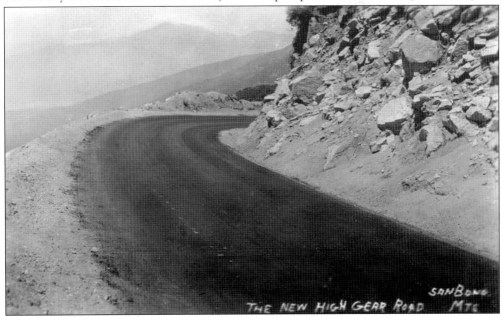

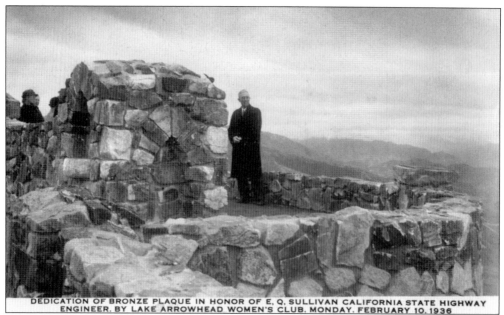

DEDICATION OF BRONZE PLAQUE IN HONOR OF E. Q. SULLIVAN CALIFORNIA STATE HIGHWAY ENGINEER. BY LAKE ARROWHEAD WOMEN'S CLUB. MONDAY. FEBRUARY 10. 1936

RED-ROCK WALL. By the mid-1930s the high-gear roadway itself was complete. Later the scenic rock work and chains were added as part of a WPA-funded assistance program to increase the safety and beauty of the drive. As shown above, Red Rock Wall was dedicated on February 10, 1936. E. Q. Sullivan was the supervising engineer. On behalf of all mountain residents, the Lake Arrowhead Women's Club placed a bronze plaque at Red Rock Wall in honor of the completion of the critical high-gear-road link to Lake Arrowhead. As depicted on the card below, one may still sit in exactly the same spot where this model posed nearly 70 years ago. The monument may be gone, but the wall remains, and the incredible panoramic views are just as splendid today. (Below CC.)

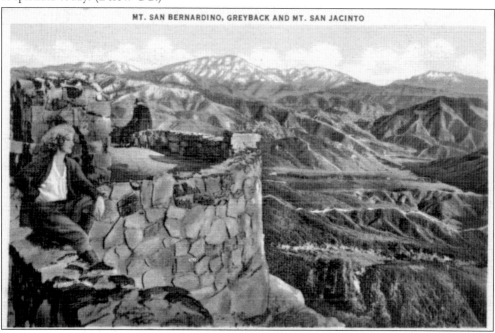

MT. SAN BERNARDINO, GREYBACK AND MT. SAN JACINTO

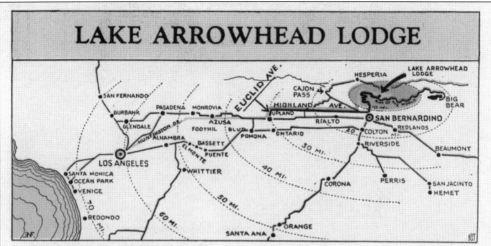

LAKE ARROWHEAD LODGE

Automobile Route from Los Angeles to Lake Arrowhead Lodge-Huntington Drive to Monrovia; Foothill Boulevard to Uplands; then North on Euclid Ave. (Double Drive) to Highland Ave.; East to San Bernardino, turn North on Arrowhead Boulevard to Lake Arrowhead. Follow blue line and watch for Lake Arrowhead Lodge signs.

"SIGNS" LEAD TO THE LODGE. The map-postcard was a popular form of advertising. The directions printed on this card are self-explanatory. Incredibly, signs were posted along the "blue line" route from Los Angeles to Lake Arrowhead, directing one to the Lake Arrowhead Lodge. This is the first of many map-postcards published for Lake Arrowhead. It was printed before construction of the High Gear Road. (BRM.)

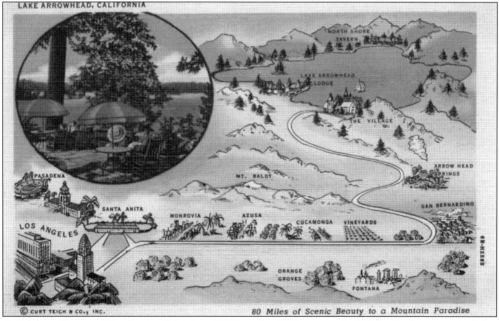

A SHORT DRIVE. The back of this late 1930s colorful linen reads, "This glorious scenic drive to San Bernardino Mountain Resorts extends 80 miles eastward from Los Angeles . . . this high gear road. . . . At every turn a panorama of the whole countryside spreads out before you in colorful splendor." (CC.)

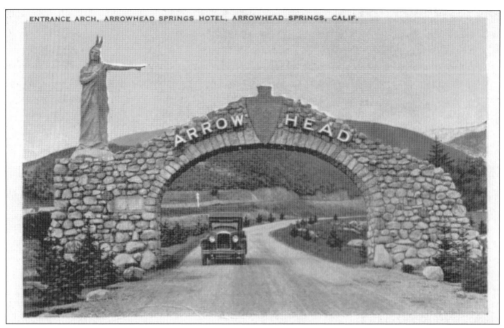

ENTRANCE ARCH, ARROWHEAD SPRINGS HOTEL, ARROWHEAD SPRINGS, CALIF.

HISTORIC ARROWHEAD SPRINGS ENTRY. En route to Lake Arrowhead, this arched entry first greeted travelers up Waterman Canyon in 1925. The Indian pointed to the arrowhead. When the Highway 18 roadway alignment was widened in 1963, the arch was destroyed and the statue removed. In 1976, the Native Sons and Daughters of the Golden West, together with new owners of the hotel, reerected the statue. (BRM.)

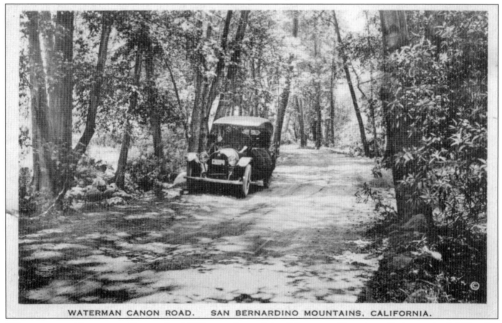

WATERMAN CANON ROAD. SAN BERNARDINO MOUNTAINS, CALIFORNIA.

WATERMAN CANYON. From the 1852 opening of the Mormon Road until the early 1930s, the only route to the mountains led up the New England–like lower Waterman Canyon. In the beginning, horses could be rested and watered amid shady groves of trees alongside the creek. Later cars would have their radiators filled and tires fixed at the same locations. (WPN.)

HIGH-GEAR GARAGE. This landmark served mountain travelers from the mid-1930s to the 1960s. Built shortly after completion of the High Gear Road, the complex included a repair shop, gas pumps, and a restaurant. The card reads, "HIGH GEAR GARAGE, SERVICE STATION—CAFÉ Day and Night Tow Service. First Stop on Rim o' the World Drive." (R.)

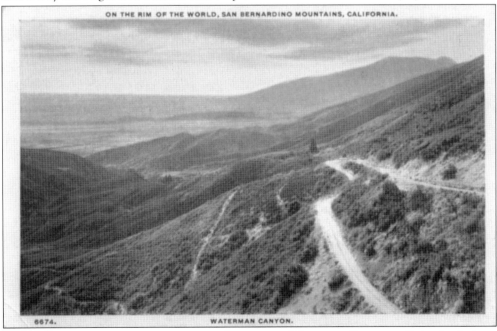

ON THE RIM OF THE WORLD, SAN BERNARDINO MOUNTAINS, CALIFORNIA.

6674. WATERMAN CANYON.

EARLY VIEW OF PANORAMA POINT. The origin of the name Panorama Point is obvious. Near the lower end of the switchbacks on the Arrowhead Reservoir Toll Road was a relatively flat piece of ground with a spectacular view. Here one could rest horses or let a radiator cool and gaze across an unspoiled panoramic view of the entire San Bernardino Valley. (PS.)

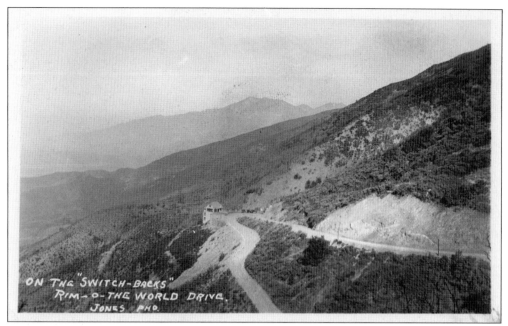

PANORAMA POINT AND PANORAMA HOUSE. This postcard shows the first phase of development of Panorama Point. Originally a flat rest area of sorts, this refuge at the beginning (going uphill) or the end (going downhill) of the switchbacks soon became a popular stopping point known as Panorama House. Here one could get fuel and food, have the car repaired, and enjoy the magnificent view.

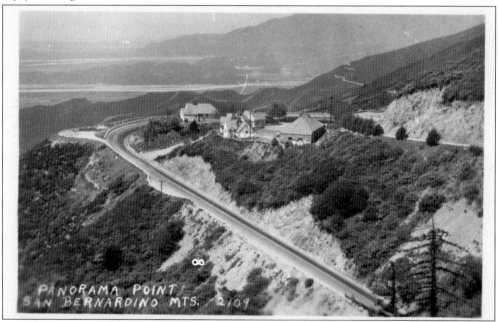

PANORAMA POINT, HIGH-GEAR ROAD. In 1928, the State of California acted to develop Panorama Point as a "park for the traveling public" on the way to Lake Arrowhead and as a place to house the state's road maintenance equipment. More than 14 varieties of trees were originally planted here as part of a roadway-beautification program.

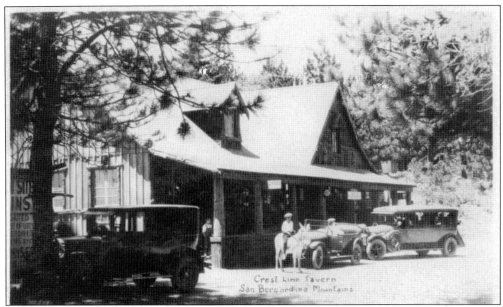

CRESTLINE ROADWAY LANDMARKS. Before the completion of the High Gear Road, all travelers to Lake Arrowhead passed through old Crestline. Today Crest Forest Drive follows the general alignment of the old Arrowhead Reservoir Toll Road as well as the first alignment of the Rim of the World Drive. Shown above is the Crest Line Tavern, converted in 1919 from a cement warehouse operated by the Arrowhead Reservoir and Power Company. It included a post office and a general store with food, clothing, and supplies. Shown below is the Rim O' the World Tavern. This was another favorite Crestline landmark for vacation travelers before construction of the High Gear Road, as it offered the first available refreshment on the way up the hill and the last on the way down. (Above AC.; below R.)

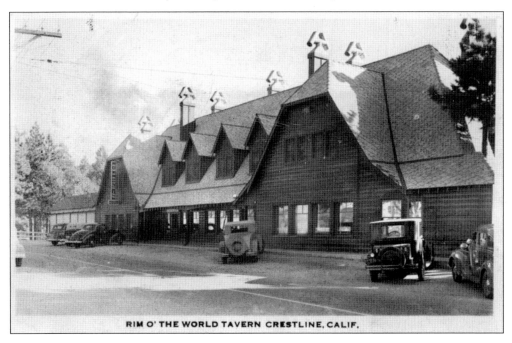

RIM O' THE WORLD TAVERN CRESTLINE, CALIF.

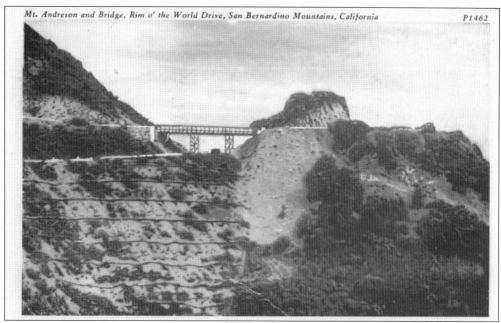

MOUNT ANDRESON INTERCHANGE. The postcard above shows the original High Gear intersection of Highways 18 and 138. An open framework steel bridge, called the Crestline Bridge or Mount Andreson Bridge, was a landmark in much the same manner that the interchange today signals to all travelers that they have arrived at the crest. John Andresen Jr. was a prominent resident who fought fires, promoted tourism, and invested in mountain property, and the steel bridge was first named after him. As shown below, the original interchange was rebuilt entirely in the late 1960s, when the four-lane roadway from San Bernardino to the crest was completed. The four-lane highway from the bottom of the hill to the Crestline Interchange was originally planned as the first link in a continuous four-lane highway extending from San Bernardino to Big Bear. (Above R.; below WRP.)

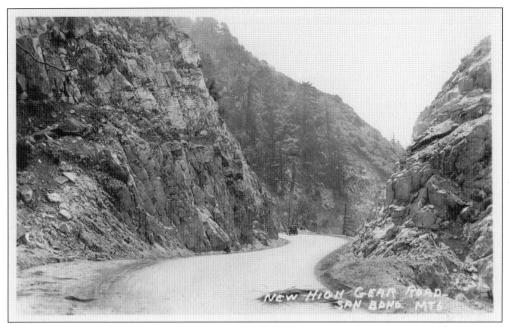

HEADING EASTERLY AT THE NARROWS. The High Gear Road section, including the narrows, was completed under the direction of district engineer E. Q. Sullivan. The roadway was touted for the unparalleled views of the valley below and for being one of the most scenic highways in the state. The picturesque stone pillars and chains adjacent to the roadway today were completed several years later.

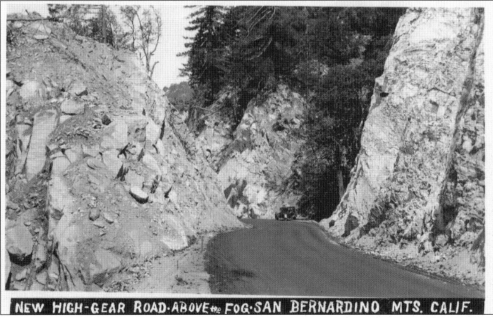

HEADING WESTERLY AT THE NARROWS. The High Gear Road link from Panorama Point to the Squirrel Inn, including the narrows, was opened to the public on May 30, 1929. The final link passing by Red Rock Wall was completed in the mid-1930s, and the entire High Gear Road alignment was dedicated in 1936.

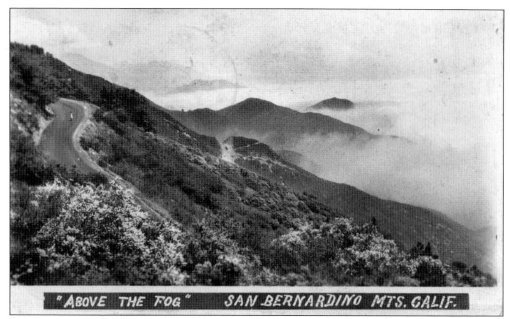

A Sea of Clouds. En route to Lake Arrowhead, nearly all Lake Arrowhead residents and most visitors to the mountains have witnessed the "sea of clouds" effect, as shown in this mid-1920s view, identified as being "above the fog." Caused by a temperature inversion, the mountains appear to be islands floating on a sea of clouds (actually fog) that has settled into the San Bernardino Valley.

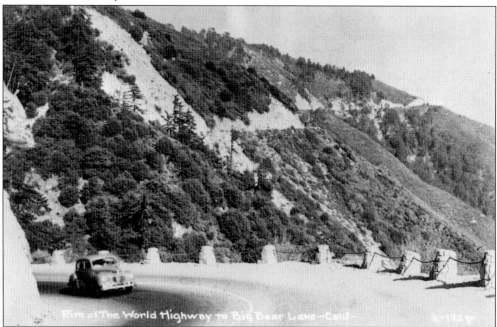

Scenic Stone Pillars and Chains. This postcard shows the section of the Rim of the World Drive extending from the Highway 138 and 18 interchange to Red Rock Wall at its scenic best. The stone pillars and chains were an effort by the state to make the drive both safe and visually pleasing. They were built with WPA assistance.

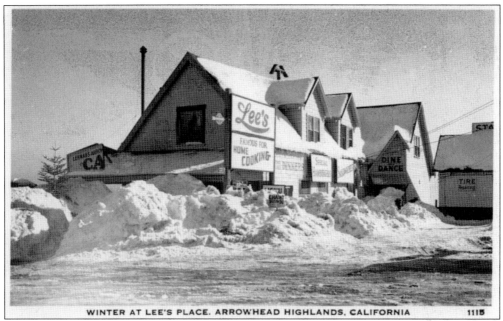

WINTER AT LEE'S PLACE. ARROWHEAD HIGHLANDS. CALIFORNIA 111S

LEE'S GARAGE. First built in 1927 as the Arrowhead Highlands Garage, this popular stopping place en route to Lake Arrowhead was known by the mid-1930s as Lee's Place or Lee's Garage. The card above shows Lee's in the early 1930s. The sign reads, "Famous for Home Cooking." Sandwiches were available, and dinners were a specialty. One could dine and dance as well as get chains put on in the snow and tires repaired. A mechanic was always on duty. The postcard below shows Lee's in the late 1940s. Not much appears to have changed since the 1930s, but a closer examination of the photograph reveals that sandwiches and ice cream cones were now the norm, and dancing was no longer an option. Today this 75-year-old mountain landmark is the site of the closed Cliffhanger restaurant.

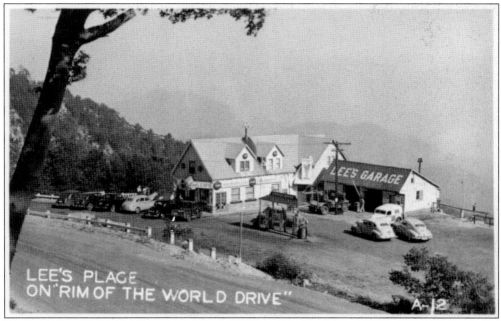

LEE'S PLACE
ON "RIM OF THE WORLD DRIVE" A-12

29

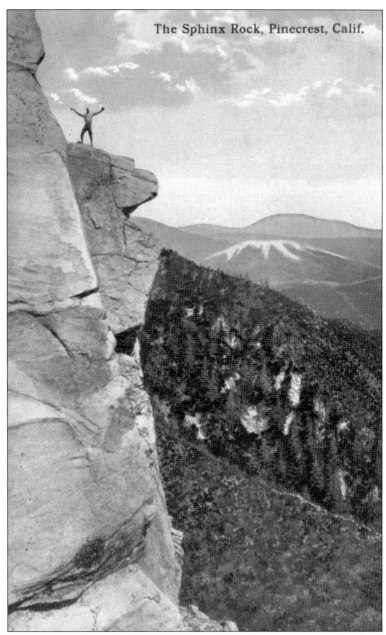

The Sphinx Rock, Pinecrest, Calif.

SPHINX ROCK. One of the most interesting natural or geologic formations in the San Bernardino Mountains is "Sphinx Rock," located near the intersection of Highway 189 and Highway 18 near the old Cliffhanger restaurant. From various angles, the head and shoulders of the famous sculpture of the Sphinx at Giza magically appear in San Bernardino Mountain bedrock. A favorite attraction and picnic spot since the 1890s, Sphinx Rock has sparked the interest of mountain tourists in much the same manner that the Egyptian Sphinx has stirred the imagination of poets and travelers. Sphinx Rock appeared in the classic 1917 movie *Eyes of the World*, directed by Donald Crisp and based on the novel by Harold Bell Wright. A 1925 guidebook notes, "At the mile-high level is a jutting lookout point, Sphinx Rock, affording a fine panorama down the San Bernardino Valley clear to the ocean." (CTP.)

Pinecrest

IN THE SAN BERNARDINO MOUNTAINS

Via San Bernardino, California

A FOREST village in the San Bernardino Mountains. Altitude, 5,480 feet. Grand view of desert, valley, mountains and distant ocean. You live in the forest in log cabins, bungalows, houses and tents. You may rent a cabin and keep house. You may board at the dining-room, or you may lease a lot and build your own home. There is a grocery store, bath-house, commodious stables and corrals, a warehouse for your summer goods, good water, a babbling brook, good roads and beautiful trails, but always you are in the mountains. For rates, etc., ask J. N. Baylis, 440 Fourth Street, San Bernardino, California.

PINECREST RESORT. The printing on this 1909 card reads, "A Forest Village in the San Bernardino Mountains. . . . You live in the forest in log cabins, bungalows, houses and tents . . . a grocery store, bath-house, commodious stables and corrals, a warehouse for your summer goods, good water, a babbling brook, good roads and beautiful trails." Pinecrest was a popular stopping and destination point on the Rim of the World Drive. (JNB.)

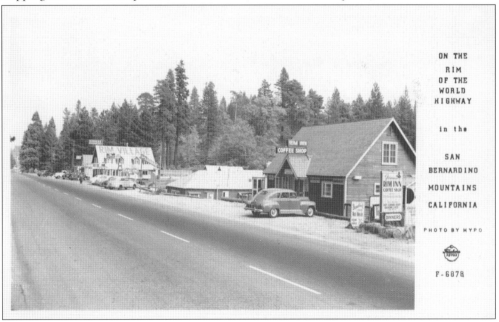

ON THE RIM OF THE WORLD HIGHWAY

in the

SAN BERNARDINO MOUNTAINS CALIFORNIA

PHOTO BY HYPO

F-6878

RIM FOREST ON RIM ROUTE. En route to Lake Arrowhead, Rimforest has long served as the last stop on the rim before getting to one's destination, or the first stop after leaving Lake Arrowhead on the way down the hill. This late 1940s postcard depicts several buildings still standing, including the Cottage restaurant. (FI.)

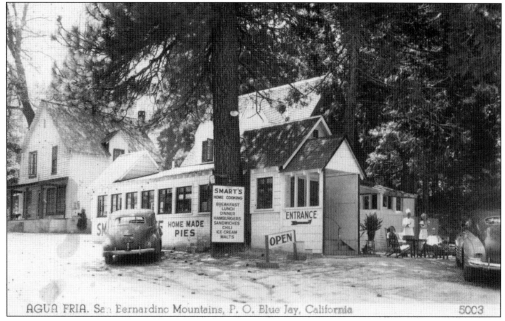

SMART'S IN AGUA FRIA. Smart's Cafe advertised "Home Cooking: Breakfast, Lunch, Dinner, Hamburgers, Sandwiches, Chili, Ice Cream, Malts, and Home Made Pies." The back of this postcard, sent by one of the owners of Smart's in 1950, reads, "This is the way our place looks now. . . . Business is picking up." Smart's is now the hardware store in Agua Fria. (R.)

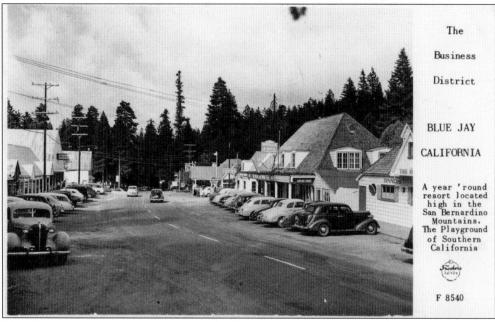

THE GATEWAY TO LAKE ARROWHEAD. This mid-1940s view shows the business center of Blue Jay, which has long served as the gateway to Lake Arrowhead and as a supply point for visitors and residents alike. The name of this community, which was homesteaded in 1914 by the Wixom family, was officially changed from Wixom Corner to Blue Jay in 1924, when the post office opened. (FI.)

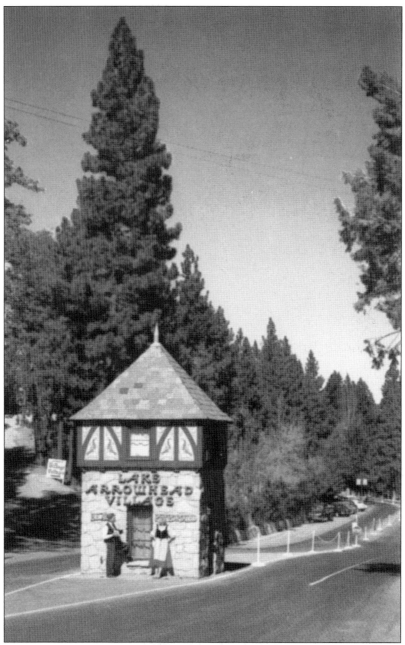

The Entrance to Lake Arrowhead. The village entrance is the true end of the road to Lake Arrowhead. This 1950s chrome depicts the main entry. The village offered the visitor a Norman-English architectural-design scheme. In reality, no English villages exist in a mountain or alpine setting, but the public quickly bought it and has done so ever since. Hollywood could not have created a more fanciful and reality-suspending design theme. The success of the village was twofold. First, the High Gear Road made what had only a few years earlier been a daylong trip into one that took only minutes. Second, the resort was open to all who had a car, and by the mid-1950s, this included most middle-class families. This may be the end of the road, but it may also be regarded as the beginning of a visitor's Lake Arrowhead adventure. (ROW.)

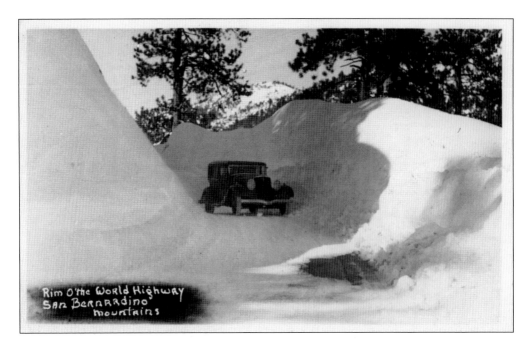

CAR IN A MAZE. Winter travel in the mountains can be hazardous today, but before the development of modern snow-removal techniques, it was really a headache. The automobile depicted in the postcard above appears as if it's in some sort of maze. This path may well have been cleared by a rotary snowplow, creating a tunnel-like effect. Newspaper articles in the late 1920s and early 1930s record several heavy mountain storms that virtually paralyzed travel for over a week at a time. The postcard below shows several state highway work crews in the process of clearing a tunnel like the one depicted above. (Above and below FI.)

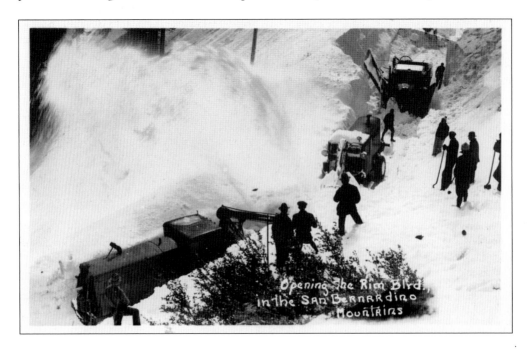

Two

IN THE BEGINNING

The "arrowhead," a natural geological formation, attracted Native Americans to this spiritual location. Springs abounded in the vicinity, and to these were attributed wonderful healing powers. Over time, a series of hotels have been built below the arrowhead. The original mid-1860s infirmary/hotel and a second hotel were both casualties of devastating fires. A third hotel, built in 1905, together with the arrowhead, became the subject of many early postcard images.

By the early 1890s, the area that was to become Lake Arrowhead was controlled by a group of Cincinnati-based visionaries who sought to sell San Bernardino Mountain water to customers in the valley. Their company, the Arrowhead Reservoir Company, took its name from the arrowhead itself. These men, along with other local entrepreneurs, formed the Arrowhead Mountain Club, and, in the early 1890s, they constructed a large clubhouse with spacious cabins for their private use and enjoyment. This private resort was named the Squirrel Inn.

In 1904, after years of planning and preparation, construction on the main corewall dam began. The formation of Little Bear Lake (now known as Lake Arrowhead) behind an ever-rising dam quite naturally led to fishing. Dam workers were likely the first anglers, and, by 1911, fishing rights had been granted to a privileged few. By about 1915, their success led to requests for increased access. The problem was quite simple. Although the lake, including all surrounding shoreline, was considered private by company officials, it was impossible to keep thousands of sport fishermen out. Lawsuits were filed, and the renamed Arrowhead Reservoir and Power Company realized very quickly that bad publicity associated with keeping the lake off-limits would not be in their best interest. Accordingly, they opened portions of the lake to the public for fishing and boating in 1915. Development plans for a small, rustic tent-camping community were also implemented. Ultimately a permanent post office, restaurant, and hotel were also built. The San Bernardino Mountain community of Little Bear Lake flourished as a sportfishing and hunting paradise.

This chapter features some of the earliest postcards associated with Lake Arrowhead, depicting resort tents, cabins, camps, activities, and amenities during the pioneer years at Little Bear Lake.

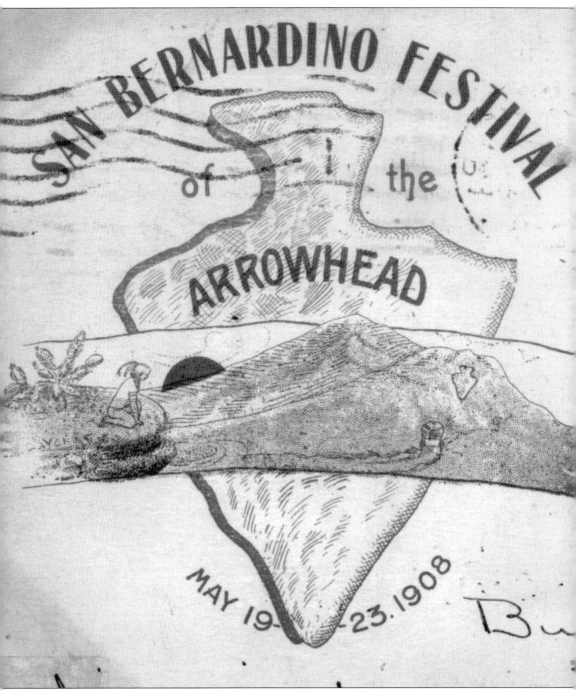

FESTIVAL OF THE ARROWHEAD. This postcard, commemorating the San Bernardino Festival of the Arrowhead (held May 19–23, 1908) includes a detailed description of the arrowhead on the message side or back of the card. It reads, "By actual measurement, the Arrowhead is 1375 feet long, and 449 feet wide, comprising an area of 7½ acres, and the material of which it is composed is different in formation from adjacent parts of the mountain, consisting chiefly of disintegrated white quartz, and light grey granite, and supporting a growth of short white

A Legend of The Arrowhead

In the days of long ago, the Cohuillas dwelt across the mountains to the southward near the San Luis Rey Mission. They were continually harassed by their warlike neighbors who stole their ponies, devastated their fields and burned their jacales. For many years they lived unhappy and in constant fear, until at last the persecutions could no longer be endured, and at command of their chief, the tribesmen gathered in council for the purpose of calling upon the God of Peace to assist and direct them to another country where they might acquire a quiet home land. Now being a gentle people, so the tale runs, they found special favor with the Great Spirit, by whom they were directed to travel northward, and instructed that they would be guided to their new home by a fiery arrow, for which they must be constantly watching. Accordingly the tribe started upon the journey, and one moonless night when the camp sentries had been posted with usual injunctions to be watchful, there appeared across the vault of heaven, a blazing arrow, which took a course northward, settling upon the mountain, where the shaft was consumed in flame, but the head imbedded itself, clear-cut, in the mountain side. The camp was roused, and while yet the morning star hung jewel-like in the sky, and a faint gleam of light in the east heralded the approach of day, they resumed their journey to the promised land, under the shadow of the mountain, where they located and lived in peaceful contentment until the coming of the white settler.

sage and weeds. This lighter vegetation shows in sharp contrast to the dark green growth of surrounding chaparral, and greasewood. The wonderfully formed symbol, so distinctive a feature of our city, is plainly visible for many miles." This is an extremely early San Bernardino Mountain–related postcard. The printed front of the card provides a historically and ethnographically inaccurate but fascinating history of the arrowhead. (MDT.)

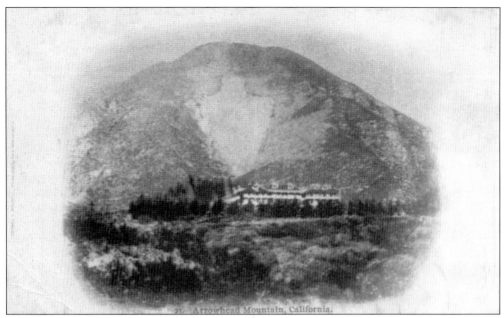

SECOND ARROWHEAD SPRINGS HOTEL. This card depicts the second of four hotels to occupy the same site. As in nearly all early images of the hotel, the arrowhead is prominently featured. This second hotel was built beginning in 1886, and it burned to the ground on July 4, 1895. At the time of the fire, it was the largest hotel in the San Bernardino area.

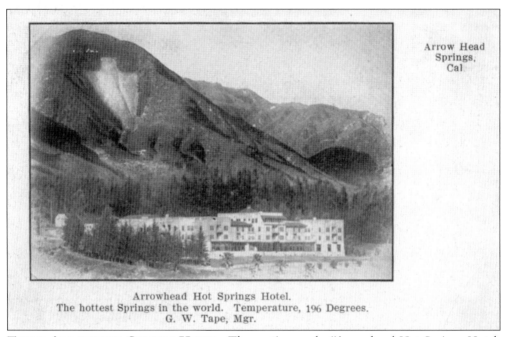

THIRD ARROWHEAD SPRINGS HOTEL. The caption reads, "Arrowhead Hot Springs Hotel. The hottest Springs in the world. Temperature, 196 degrees. G. W. Tape, Mgr." A post office was established at the hotel in 1887 with the name Arrow Head Springs. In 1907, the name was changed to Arrowhead Springs.

CALIFORNIA'S IDEAL RESORT. The back of this card proudly advertises, "Water highly radio active." This was apparently a good thing. A 1910 letter from Gilbert E. Bailey, University of Southern California professor of geology, to Mr. Seth Marshall, president of the Arrowhead Hot Springs Company, states, "The work of the past two months shows that the mud's from the Mud Cienega, and the waters of Penyugal Springs contain radio-active substance." (NPC.)

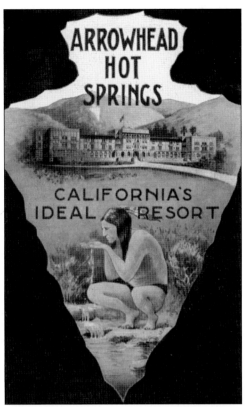

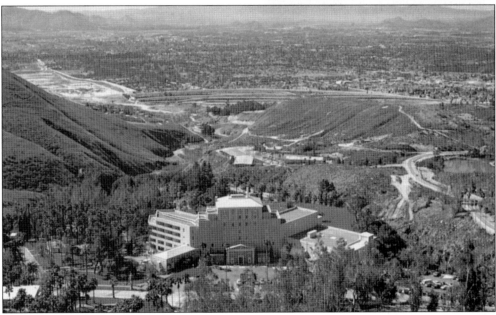

FOURTH ARROWHEAD SPRINGS HOTEL. In November 1938, a devastating fire swept down the mountainside. When the fire reached the arrowhead, guests fled, and when the fire reached the hotel, employees and firemen also fled. As before, a bigger and better hotel rose like a phoenix from the ashes. In December 1939, the new six-story Arrowhead Springs Hotel opened. (MRC.)

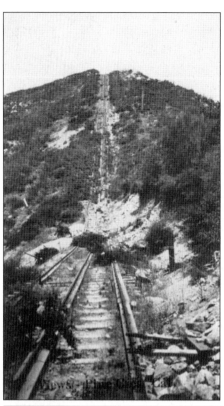

THE INCLINE RAILWAY. In 1906, the Arrowhead Reservoir and Power Company built a three-rail incline railway to haul heavy construction materials (concrete, steel, etc.) for the Little Bear Lake dam and water-distribution system. The incline extended from upper Waterman Canyon to a point near Skyland, directly above the existing Highway 138/18 interchange. In 1907, due to engineering and operational difficulties, company officials abandoned the alignment.

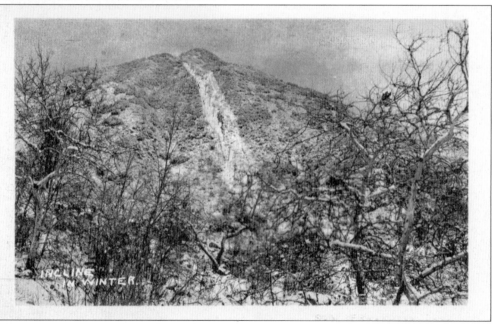

THE INCLINE IN WINTER. This early postcard shows the path of the incline railway leading toward the top of Mount Andreson. The Incline post office, the first on the west end of the mountaintop, opened on June 18, 1907. It was located in the area known today as Skyland. In April 1910, the name was changed to Skyland Heights. (JP.)

40

LITTLE BEAR VALLEY AND LAKE. The first use of the mountain place name "bear" is attributed to Benjamin Wilson's 1845 name for Baldwin Lake. Tracking renegade Native Americans into the San Bernardino Mountains, Wilson encountered over 20 bears near this lake. Big Bear Lake was eventually named following construction of a huge reservoir, and the name Little Bear Lake for a smaller mountain lake seemed appropriate.

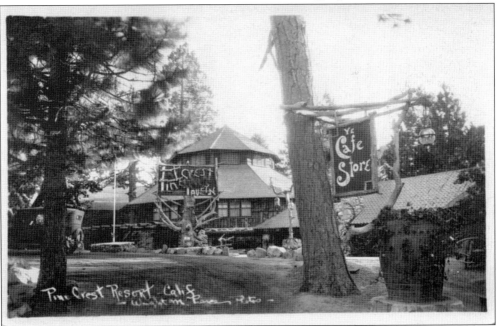

THE PINECREST RESORT. In 1904, Dr. John N. Baylis, a Squirrel Inn devotee, purchased 160 acres adjacent to the Squirrel Inn. In 1906, he began building Pinecrest, one of the most successful resorts open to the general public in the San Bernardino Mountains. The tall building featured in this early postcard remains standing today.

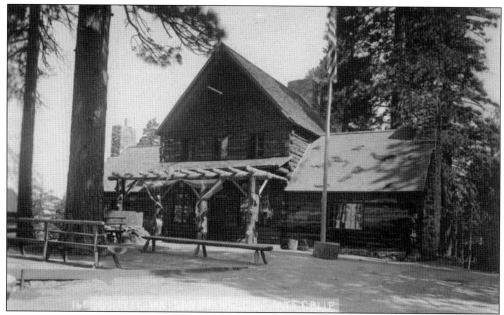

THE SQUIRREL INN. Constructed in the 1890s by the Arrowhead Mountain Club, the Squirrel Inn got its peculiar name from a fictional hotel in Frank Stockton's popular novel. Apart from many Arrowhead Reservoir Company officials, members included "high rollers" from the San Bernardino area, including Dr. John Baylis and Seth Marshall, owner of the Arrowhead Hot Springs Hotel. (BVP.)

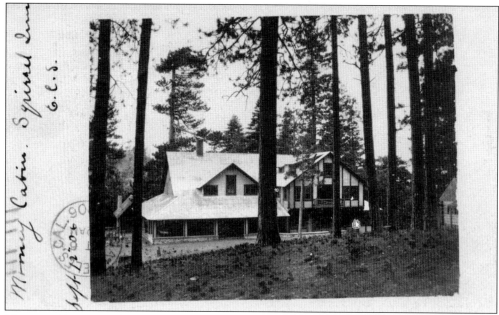

MOONEY CABIN AT SQUIRREL INN. As shown on this card postmarked October 1906, James Edgar Mooney, one-time president of the Arrowhead Reservoir and Power Company, built a large and beautifully finished and appointed cabin here. Squirrel Inn members were very well-heeled indeed. Membership cost nearly as much as most families made in a year, and the "cabin" was big enough to serve as an inn.

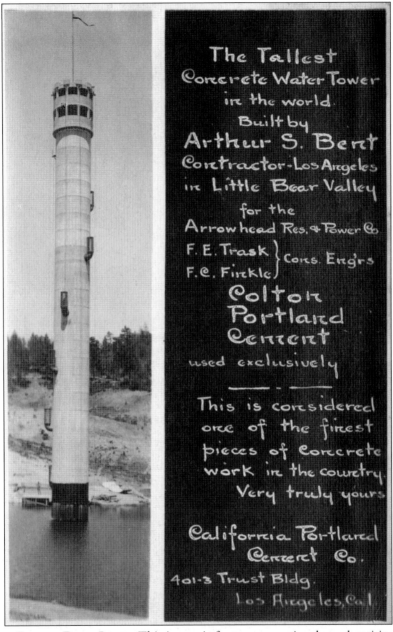

The Tallest
Concrete Water Tower
in the world.
Built by
Arthur S. Bent
Contractor-Los Angeles
in Little Bear Valley
for the
Arrow head Res. & Power Co
F. E. Trask } Cons. Eng'rs
F. C. Finkle }
Colton
Portland
Cement
used exclusively
___ - ___
This is considered
one of the finest
pieces of Concrete
work in the country.
Very truly yours,
California Portland
Cement Co.
401-3 Trust Bldg.
Los Angeles, Cal.

TOWER AT LITTLE BEAR LAKE. This image is from a promotional or advertising postcard. The typed postcard message states, "The tallest concrete water tower in the world. Built by Arthur S. Bent contractor—Los Angeles in Little Bear Valley for the Arrowhead Res. & Power Co. F. E. Trask (and) F. C. Finkle Cons. Eng'rs. Colton Portland Cement used exclusively. This is considered one of the finest pieces of concrete work in the country. Very truly yours, California Portland Cement Co. 401-3 Trust Bldg., Los Angeles, Cal." The handwritten message on the back reads, "November 23, 1908—Compare the height of the man on the ground with the height of the tower." The man on the ground is just to the left of the tower and is approximately one-eighth of an inch high on the original card. This is a rare card from the Little Bear Lake pioneer period, providing one of the earliest views of the intake tower.

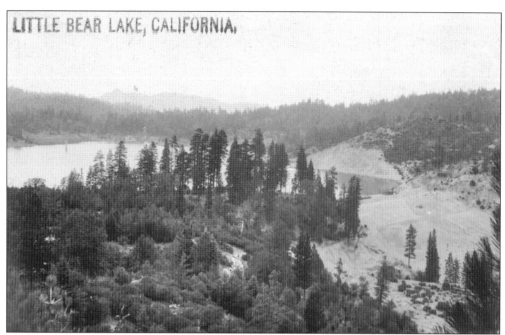

LITTLE BEAR LAKE AND DAM. The Arrowhead Reservoir Company, organized in December 1890, then included James Gamble of the Proctor and Gamble Soap Company as its president. In 1904, work began on the dam (visible on the right), which would create Little Bear Lake, later known as Lake Arrowhead.

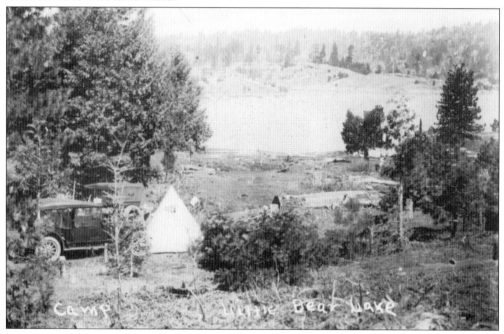

CAMP, LITTLE BEAR LAKE. By around 1911, Little Bear Lake was attracting unwanted campers and fishermen. Though investors were less than enthusiastic, public pressure combined with bad publicity eventually convinced the Arrowhead Reservoir and Power Company to open portions of the private lake to all comers in 1915.

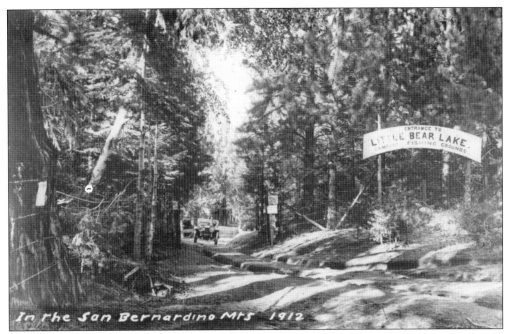

ENTRANCE TO LITTLE BEAR LAKE. This postcard shows the entrance sign welcoming visitors to the Little Bear Lake–resort complex. The sign reads, "Entrance to Little Bear Lake: Camping, Fishing Grounds." This is a republished postcard, and the 1912 date at the bottom is likely incorrect. The view was probably captured after 1915.

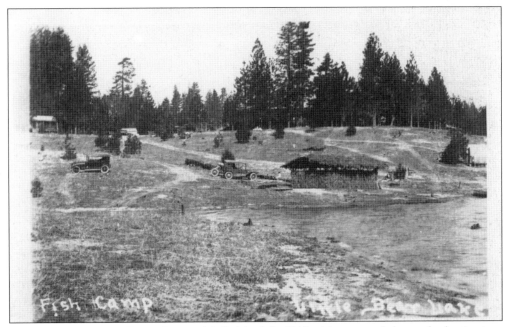

FISH CAMP, LITTLE BEAR LAKE. Mailed in July 1918, this postcard shows the beginnings of the Little Bear Resort. This card was mailed from the Little Bear Post Office, which had opened in February 1917. The message states in part, "I sure was afraid climbing the mountains in the car, and I'm afraid I'm going to get cold feet going home."

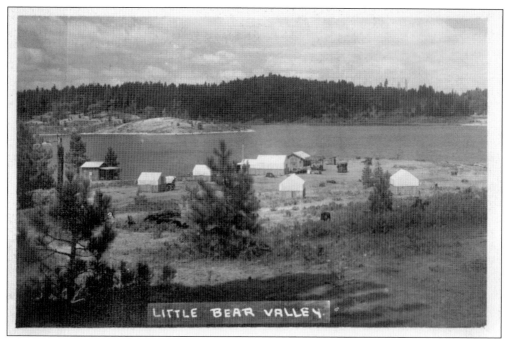

LITTLE BEAR RESORT. This card provides an overview of the resort area on the southern peninsula of Little Bear Lake *c.* 1916. At this time, entrepreneurs Gus Knight and Fred A. Edwards had secured certain concession rights, including boat and tent rentals, from the Arrowhead Reservoir and Power Company. (BVP.)

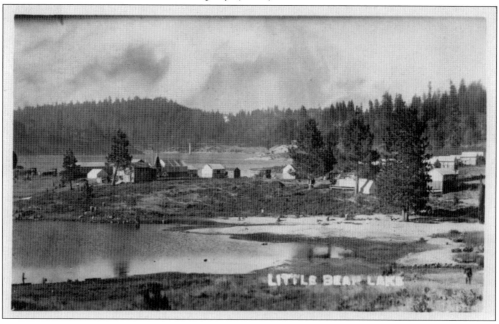

PRIMITIVE LITTLE BEAR LAKE RESORT. This overview shows virtually the entire Little Bear Resort complex *c.* 1917. The intake tower is in the background. Tent houses are everywhere, and other more permanent structures are visible. The lake had not yet filled, and it was not until 1920 that the body of water first reached its currently maintained level.

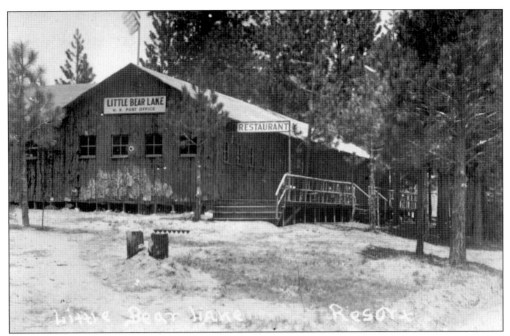

RESTAURANT AND POST OFFICE. In this image, the resort restaurant and post office, which opened on February 16, 1917, are shown in detail. Fred A. Edwards was the first postmaster, and he quickly built a hotel and dance pavilion.

LITTLE BEAR LAKE RESORT AND CABINS. The main road into the Little Bear Lake Resort is clearly shown in this image. The building at the end of the road (right) is the post office and restaurant. At this point in time, about 1918, several miles of shoreline were open to public fishing and the lake was stocked with trout.

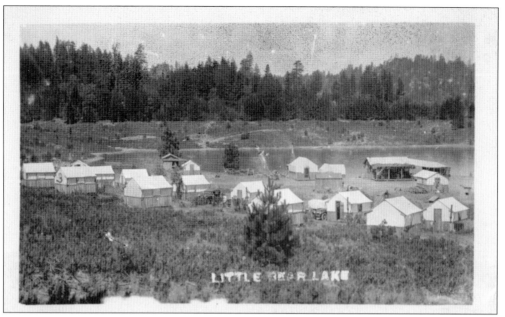

LITTLE BEAR LAKE. This image is taken from a postcard mailed on July 14, 1916, to Marblehead, Massachusetts, from the Skyland Heights post office in Crestline. The Little Bear Lake Post Office had not yet opened. The image is one of the earliest of the Little Bear Resort, located about where Lake Arrowhead Village is today.

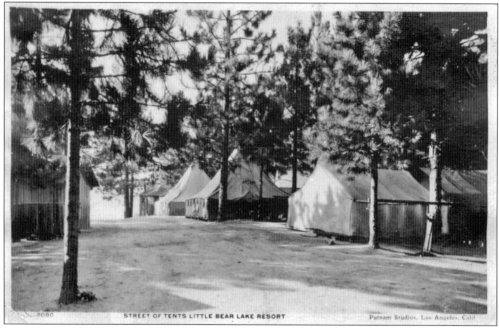

STREET OF TENTS. Postmarked "Little Bear," August 15, 1921, this card is titled "Street of Tents Little Bear Lake Resort." The back reads, "Ethel & Milton went home Sunday. They certainly wanted to stay longer. My fisherman has gone home, so I might as well go too." At this time, the holdings of the Arrowhead Reservoir and Power Company had already been secured by Los Angeles investors.

Three

THE VILLAGE AT
LAKE ARROWHEAD

In 1921, Little Bear Lake and all of the associated Arrowhead Reservoir and Power Company properties were sold to a group of Los Angeles businessmen. Times had truly changed—their vision was new and astounding. The new investors imagined the development of the lake not for the purpose of selling water, as their predecessors had, but as a purely recreational destination. They planned a world-class resort for all, with boat rentals, fishing, camping, a golf course, horseback riding, hunting lodges, restaurants, shops, and just about everything else the young or old, rich or poor could enjoy.

The success of Lake Arrowhead as a resort concept was dramatic and quick, beyond the dreams of even the most optimistic investor. Lake Arrowhead was unique, and it was within relatively easy reach of one of the largest and most mobile populations in the United States. Southern Californians have always had a love affair with the automobile, and Lake Arrowhead investors had the genius to recognize this before almost everyone else. They also made sure that visitors would be greeted with all of the creature comforts.

A 1924 brochure published by the exclusive Mountain Lake Club describes Lake Arrowhead as "Different in every way from one's conception of a mountain town, provision for all civic utilities was included in the development of the place for the convenience of the people. Electric light, running water, telephone service, radio receiving station, sewerage, waste collection, fire protection, town police—are just a few of the comforts enjoyed by the inhabitants of Lake Arrowhead."

By the mid-1920s most of the major recreational activities and resort amenities were completed. Development continued throughout the 1930s and 1940s despite the intervention of World War II. The post-war years were, however, the most impressive yet.

THE HEARTH AND HUB. The back of this card is titled, "The Hearth and Hub, Lake Arrowhead." It continues, "California's Finest Playground, Lake Arrowhead, California, Elevation 5120 feet, 86 Miles From Los Angeles." The same basic text would be used on many different cards. Note the "casino" steeple in the background.

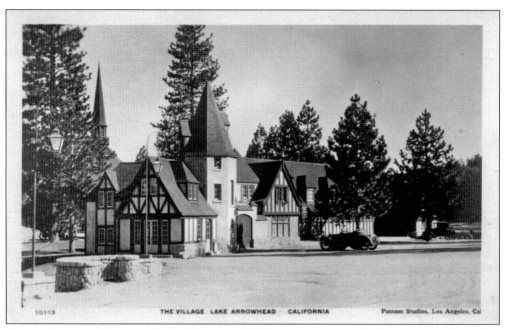

EARLY VIEW OF VILLAGE. Lake Arrowhead Village was ceremonially opened on Saturday, June 24, 1922. Festivities included speeches, music, and tours. Friend Richardson, soon to be the governor of California, was in attendance. (PS.)

50

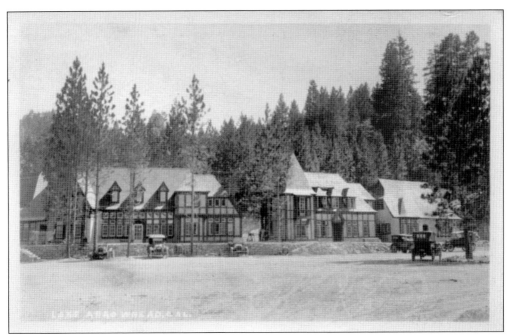

MAIN VILLAGE PARKING AREA. The village initially consisted of a stage depot, post office, hardware store, tackle shop, market, drug store, art shop, cafeteria, gas station, offices, and a dance pavilion. Living quarters for employees and the maintenance staff were available on the second stories above the main or ground floors of select buildings. At the very beginning, parking was more than adequate.

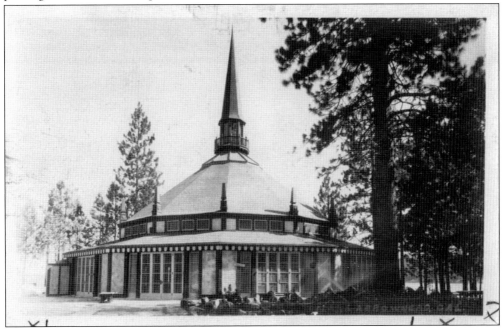

THE DANCE PAVILION. Architect McNeal Swasey designed a 12-sided dance pavilion for the village. The Howard Patrick and Blondy Clark Orchestra played at the 1922 Fourth of July dedication of the pavilion. Later known as the "casino," this building stands today.

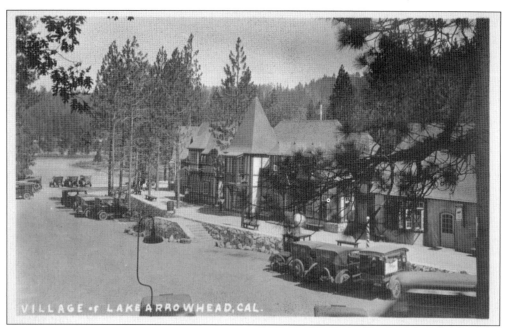

MODERN COMFORTS AMID PRIMAL BEAUTY. This card underscores the relationship of the village to the forest. In a speech to San Bernardino County Supervisors, Morgan Adams, president of the Arrowhead Lake Company, declared that he was honored to "take a virginal wilderness and give it modern comforts without intruding on its primal beauty." This card also proves that a person could have any color car, as long as it was black.

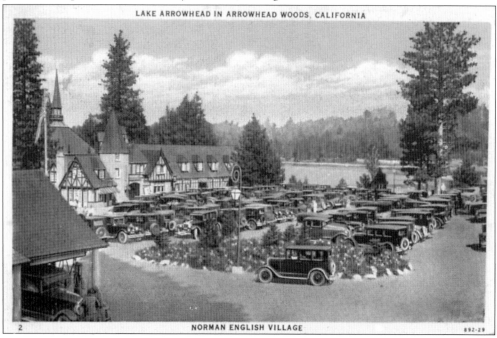

MOTOR TRANSIT STOP. In 1922, the Motor Transit Company offered two round trips daily to Lake Arrowhead from San Bernardino. The motor transit stop is at the lower left of the image. (PS.)

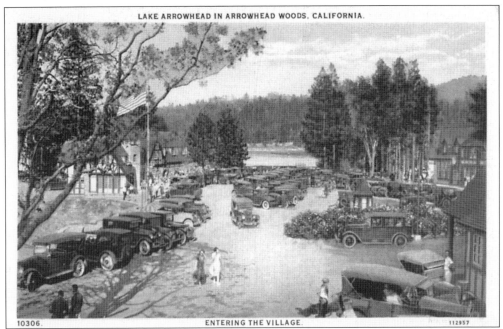

10306. ENTERING THE VILLAGE. 112957

PARKING BECOMES A PROBLEM. Summertime in the village could be glamorous indeed, but parking became quite an ordeal. Here cars are parked haphazardly. Lake Arrowhead developers, architects, and planners thought they had covered every contingency, but by the mid-1920s, all facilities would reach their limits on holiday weekends. (PS.)

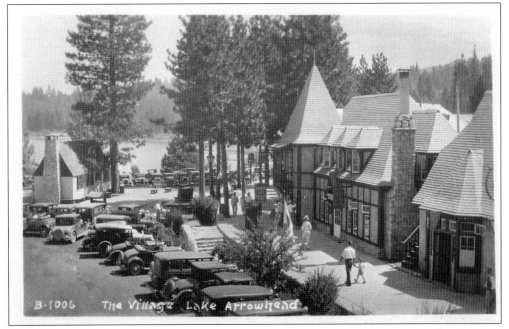

B-1006 The Village Lake Arrowhead.

THE 1930s VILLAGE. The back of this card reads, "The Village is the center of activities— everyone has freedom of bathing suits—quite crowded—where we parked each day to go for a swim." This is interesting information indeed. The freedom to wear bathing suits in all stores and shops, or in public places, was clearly regarded as unusual.

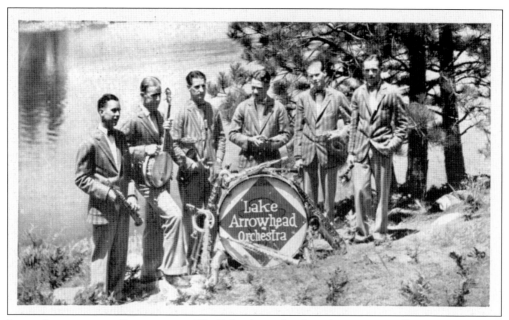

LAKE ARROWHEAD ORCHESTRA. The Lake Arrowhead Orchestra was really more of a group of collegiate friends who played nightly in the dance pavilion in the summer. The goal was to attract a younger crowd, and to this end the orchestra was successful. With striped jackets and hair parted down the middle, these young men strike a dramatic pose. (NC.)

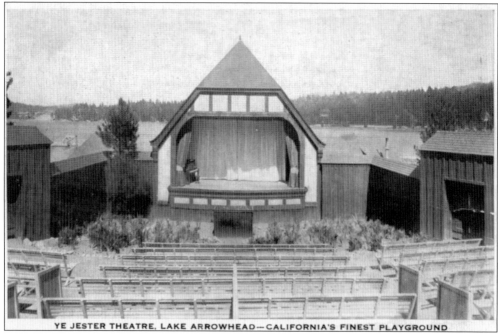

YE JESTER THEATRE, LAKE ARROWHEAD—CALIFORNIA'S FINEST PLAYGROUND

YE JESTER THEATER. Built about 1926, the Ye Jester outdoor theater featured wood bench pew-like seating and an upright piano for live music. Recently the theater has been re-created as the "Center Stage," where free concerts have brought many new visitors to the village. (NC.)

ARCHITECTURAL RESTRICTIONS. A 1926 Arrowhead Lake Company brochure, titled "Lake Arrowhead—questions and answers," reads under the "Restrictions" heading, "What are the architectural restrictions?" The answer is, "Architecture must conform to Norman English type, and every plan drawn for a house to be built in Lake Arrowhead Woods must be submitted to the Architectural Committee of the Arrowhead Lake Company and passed on before the work begins."

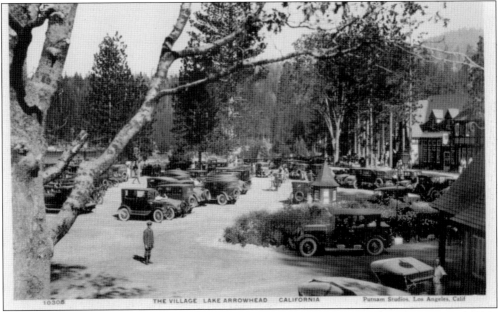

VILLAGE OVERVIEW. This view is similar to dozens that were published during the 1920s and 1930s showing the village as crowded (empty was not a good thing for promoters to underscore). This card differs, however, in one respect. The man standing alone in the foreground unintentionally drives home the fact that Lake Arrowhead really was different than other mountain resorts when attendants stood by in the village parking lot. (PS.)

55

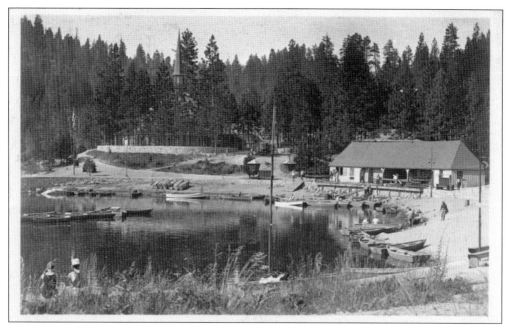

VILLAGE BAY AND BOATHOUSE. This 1924 view shows both the boathouse and the steeple of the casino. The village bay housed rowboats available for rent. These were used primarily for fishing, and the fishing season was open from the beginning of May to the beginning of November.

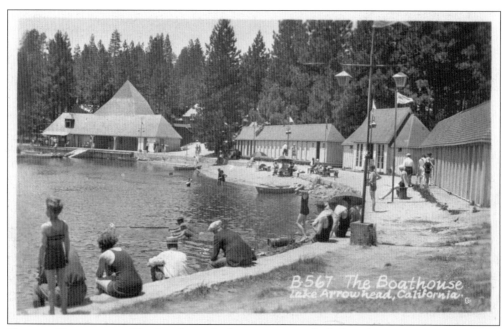

VILLAGE BOATHOUSE. The boathouse is the structure to the left in this image. The structures on the right were the men's and women's bathhouses. The peaked structure behind the boathouse is the Ye Jester Theater.

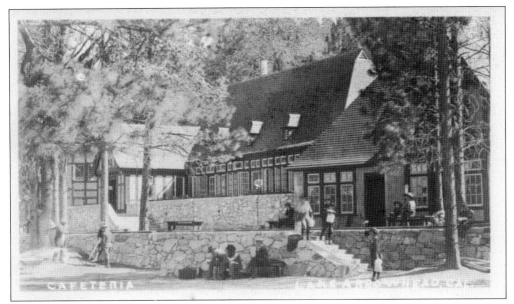

VILLAGE CAFETERIA. By 1926, the village had a beauty parlor, telegraph office, real estate office, delicatessen, meat-and-grocery market, drugstore, soda fountain, sandwich shop, sports-goods store, cleaning-and-pressing establishment, barbershop, and even a place to get your shoes shined. This is the "cafeteria."

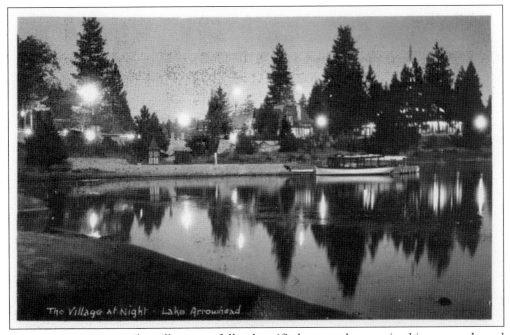

VILLAGE AT NIGHT. The village was fully electrified, as can be seen in this very early and rare view of the village at night. To the right/center of the image is the excursion boat the *Blue Jay*.

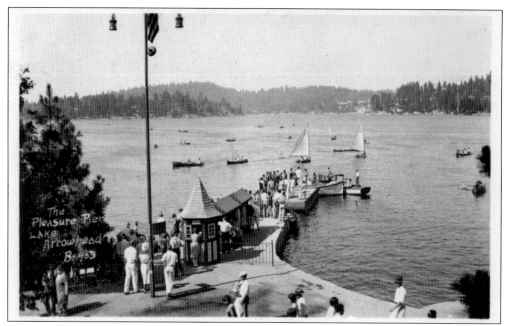

PLEASURE PIER LAKE ARROWHEAD. The village is located on a peninsula with the shores of Lake Arrowhead on three sides. This postcard shows visitors purchasing tickets and waiting for a guided boat tour around Lake Arrowhead. Before the current *Arrowhead Queen* offered tours, at least three other excursion boats did so.

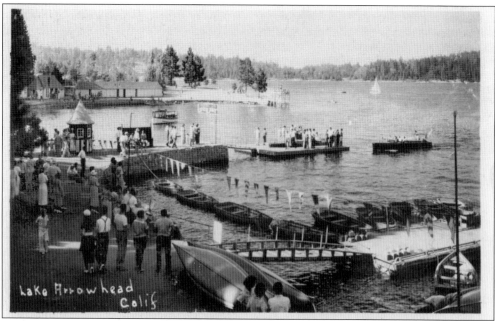

VIEW OF THE VILLAGE BAY. This 1938 image shows almost everything that was happening in the village bay. The curving peninsula at the top is where a diving tower was erected. This later became the spot where the McKenzie Water Ski School was located. In a counterclockwise direction from there were the bathhouses, a boathouse, the Pleasure Pier, and a dock where boats were available for rent.

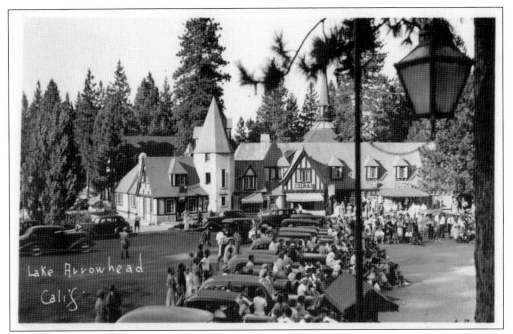

VILLAGE LANTERNS. In 1930, the village was enlarged and upgraded. One of the old village lanterns is visible in the foreground. When the village was burned in a "burn to learn" fire-department exercise in 1979, these lanterns were auctioned off. They sold for around $2,000 each and are still seen on homes around Lake Arrowhead.

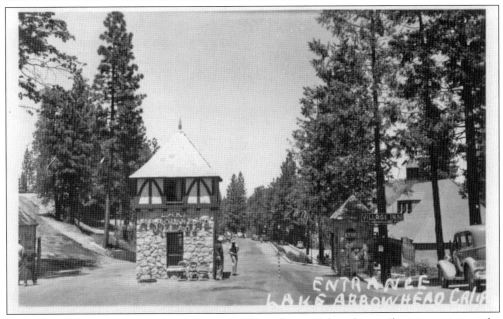

THE VILLAGE ENTRANCE. An entrance kiosk used to stand at the southern entrance to the village. This kiosk stood a little farther into the village proper than today's entrance does. After the Irvine-based G. C. Properties bought the village in the late 1970s and the decision was made to raze the "Old Village," an offer was made to purchase and move this historic entrance. However, within a few weeks after the purchase, the structure was destroyed.

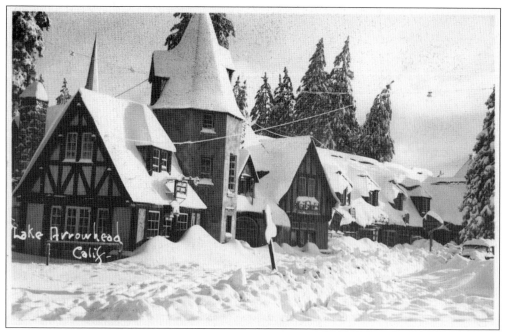

SNOW SCENE IN 1920s. Seasonal snow is depicted in this early view of the village. Winter attracted thousands of visitors to Lake Arrowhead. A toboggan slide was located near the village, and sleds were returned to the top of the hill by cableway.

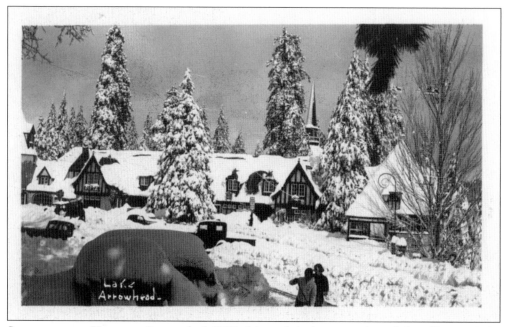

SNOW AT THE VILLAGE. Postmarked 1937, this card depicts a portion of the village at Lake Arrowhead under a blanket of snow. Two of the most severe winters recorded occurred in 1938 and 1949, when the lake actually froze over. Lake Arrowhead remains an alluring destination point, partly because it can be enjoyed during all four seasons.

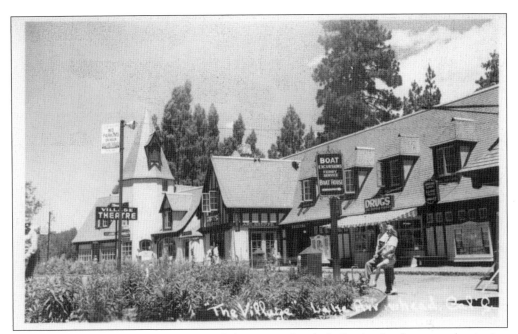

VILLAGE IN THE 1950s. This postcard shows two lovely ladies in the foreground enjoying the village. A sign points the way to the boathouse, where excursions and ferry service await. Other signs point the way to the village theater and miniature golf course. Also identified, from right to left, are Sporting Goods, Lake Arrowhead Pharmacy, and Art Shoppe and Gifts.

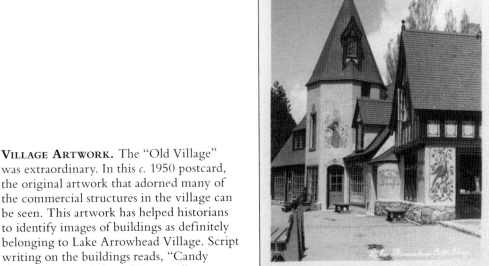

VILLAGE ARTWORK. The "Old Village" was extraordinary. In this *c.* 1950 postcard, the original artwork that adorned many of the commercial structures in the village can be seen. This artwork has helped historians to identify images of buildings as definitely belonging to Lake Arrowhead Village. Script writing on the buildings reads, "Candy Shop, Interiors, Gifts and Imports."

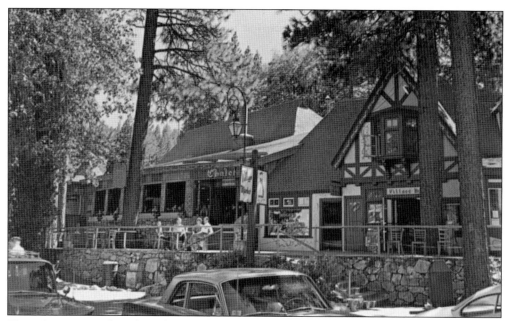

The Chalet. Other than the casino, the chalet, a world-famous restaurant and cocktail lounge, is probably the most fondly remembered building in the Old Village. Guests included Frank Sinatra and Tony Curtis. It was ideally located where customers could, as noted on the back of the card, "Look out on picturesque Lake Arrowhead Village or on the cool blue waters of the lake." (WRP.)

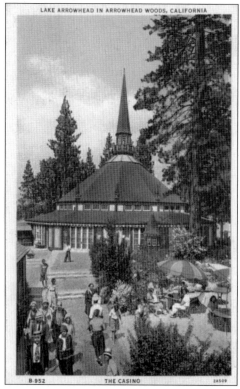

The Casino. The casino is the sole remaining vestige of the original village. When G. C. Properties bought the village, the decision was made to replace it with modern buildings rather than fix the deteriorating ones. The old village was razed in a "burn to learn" exercise in April 1979. In today's more culturally enlightened world, it is doubtful that such a tragedy would be permitted. (PS.)

Four

Resorts, Lodges, and Gathering Places

The postcards selected for this chapter are snapshots in time. They include individual components of the village and many of the major surrounding landmarks. Several of them have been demolished, closed, or altered, but some remain as special places. Regardless, they fascinated past visitors, and the character and elegance of their images provoke our thoughts today.

The original Lake Arrowhead development concept included a well-appointed—in fact, luxurious—planned community around the lake. All buildings and structures built within the carefully defined holdings of the Arrowhead Lake Company were deed-restricted. Design guidelines were among the most stringent. Individual resorts, lodges, restaurants, stores, shops, and other gathering places were all required to reference a Norman-English design.

Over the period of time extending from 1921 until Post–World War II, dozens of facilities were constructed, either with company money or by private investors with the blessing of the Arrowhead Lake Company and its successors. Hundreds of homes were also constructed, ranging from small, rustic cabins to genuine mansions.

In 1979, what remained of the original Lake Arrowhead Village was burned to the ground as part of a fire-training exercise. The owners had determined that the buildings were beyond use for modern planning, in which square footage plays out heavily against the almighty dollar. Hundreds mourned and many openly cried at the loss. Many surrounding landmarks have since been demolished, as they were considered as outdated or obsolete. These postcard images are then the true survivors and are all the more valuable as a result.

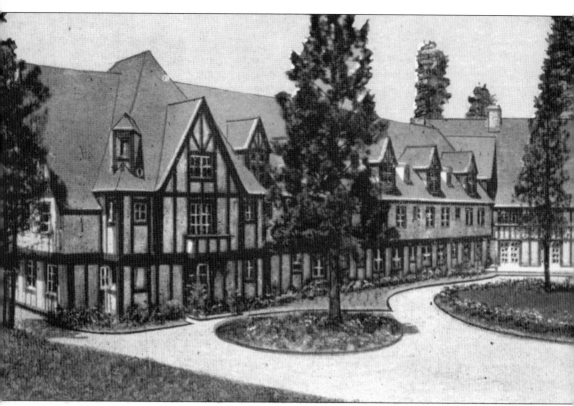

THE ARLINGTON. In 1922, A. E. Warmington, spokesman for a syndicate of Los Angeles millionaires who had recently purchased Lake Arrowhead, brought A. L. Richmond, owner of one of California's finest hotels, the Arlington in Santa Barbara, to visit the newly acquired properties. The *Saga of the San Bernardinos* recorded, "By the very nature and demand of the setting—Richmond was persuaded to undertake the building of a suitable hotel for Lake Arrowhead on the high terrace between Burnt Mill Road and the steep-gabled Normandy

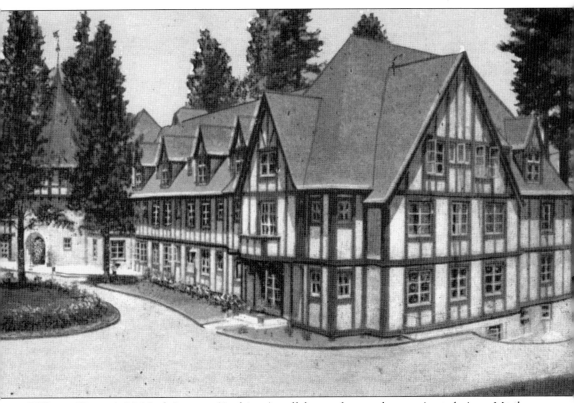

Village. He and McNeal Swasey (Architect) collaborated on a harmonious design. Much material was already on hand. Within a few weeks a double shift of 150 masons and carpenters started the task of raising a drawing to a reality." The Arlington Lodge opened its doors to affluent guests on June 23, 1923, with a midnight champagne party, the cuisine of a world-famous chef, and a dance. Guests also enjoyed the orchestra and toured the drawing rooms and the gracious bedchambers, complete with private baths. (BRM.)

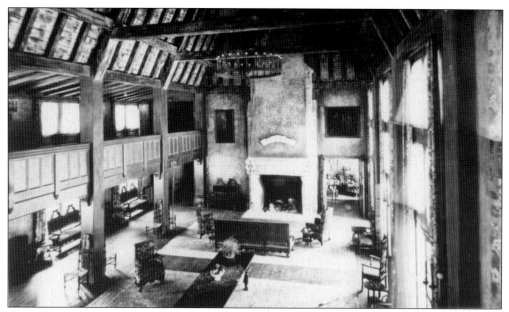

GREAT HALL OF THE ARLINGTON. Vaulting 45 feet above the luxurious rugs and flooring below, the lobby or "Great Hall" of the Arlington was an impressive architectural achievement. At one end was a massive fireplace. At the opposite end, a huge staircase swept upward to the second story. Exclusive period furniture, especially designed by Old-World craftsmen, completed the setting. (PS.)

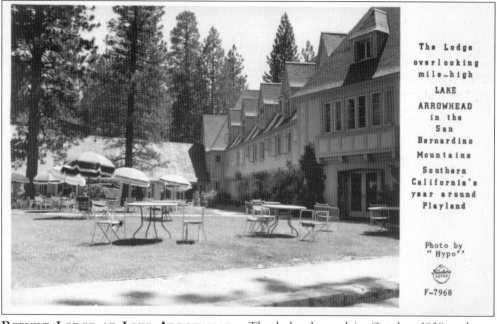

The Lodge overlooking mile-high LAKE ARROWHEAD in the San Bernardino Mountains Southern California's year around Playland

Photo by "Hypo"

F-7968

REBUILT LODGE AT LAKE ARROWHEAD. The lodge burned in October 1938 and was quickly rebuilt. Movies filmed there include *Just For You*, a 1952 film staring Bing Crosby, Ethel Barrymore, and a young Natalie Wood; *I'll Take Sweden*, a 1965 hit staring Bob Hope, Frankie Avalon, and Tuesday Weld; and the 1973 film, *A Summer Without Boys*, staring Michael Moriarty, Barbara Bain, and Kay Lenz. (FI.)

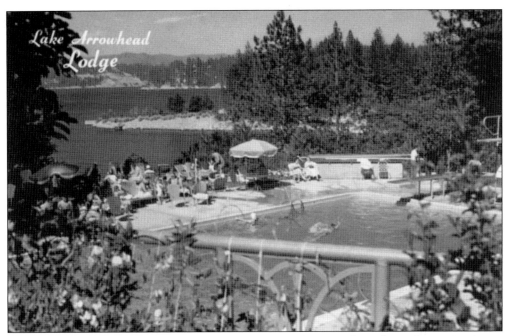

THE LODGE TERRACE. The back of this card reads, "This view from the Lodge terrace is one of the most picturesque sights in the West. Here the viewer looks across the vivid blue waters of this mile high lake in the San Bernardino Mountains surrounded by pines, cedars and oaks that grow right to the water's edge." (WRP.)

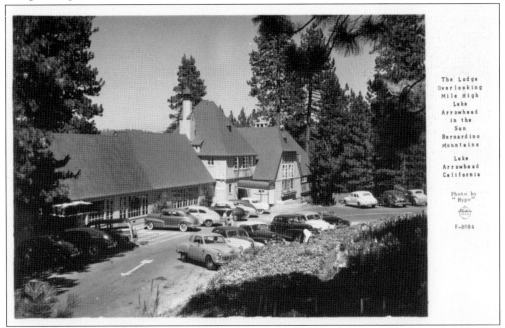

HEYDAY AT LAKE ARROWHEAD LODGE. This *c.* 1950 view shows the entrance to the lodge at its historic best. In December 1976, the lodge was torn down. The New Village opened in May 1981, and construction on the new 150,000 square-foot Lake Arrowhead Hilton Lodge began in October of that year. (FI.)

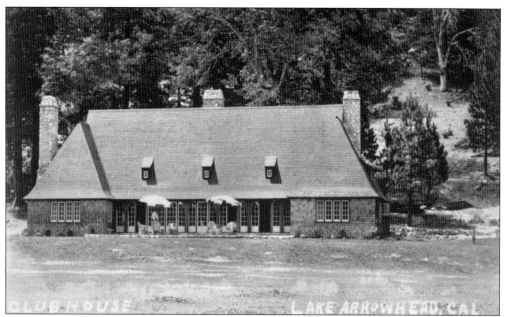

THE CLUBHOUSE, LAKE ARROWHEAD. Known initially as the Club Couse or Clubhouse, this facility served as a place to wine and dine potential buyers of Lake Arrowhead property. Facilities included a dining room, detached cabin bungalows, and, as noted in a newspaper article, "bachelors' quarters" (exact meaning unknown at the present time). This is an early view of this multifunctional facility.

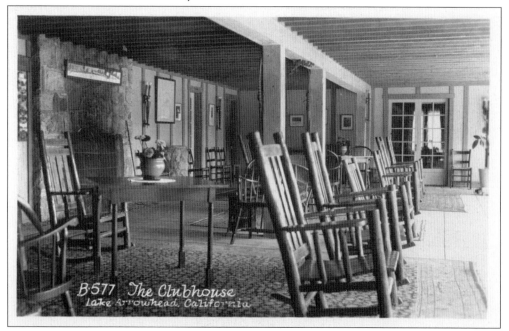

THE CLUBHOUSE VERANDAH. Here wealthy potential buyers could sit and rock, contemplating a purchase, while gazing across the lake in the distance. A freshly made cocktail or an iced drink must have tasted great in these comfortable chairs. Probably every piece of furniture in this image would be worth a small fortune today.

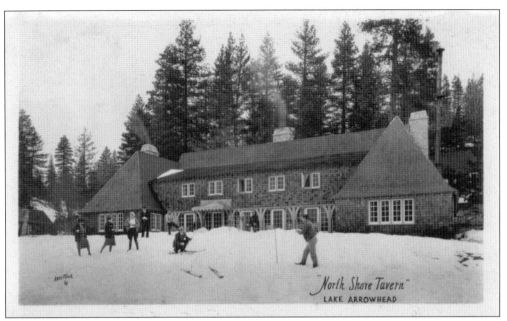

NORTH SHORE TAVERN, LAKE ARROWHEAD. By 1927, the Clubhouse had become known as the North Shore Tavern. The name "North Shore" was chosen to indicate its shoreline location, and "Tavern" was selected to evoke its hospitality. The property had an immense lawn, covered here in a deep snow, which sloped down to the shores of Lake Arrowhead. Incredibly, the men in this photograph are all wearing ties.

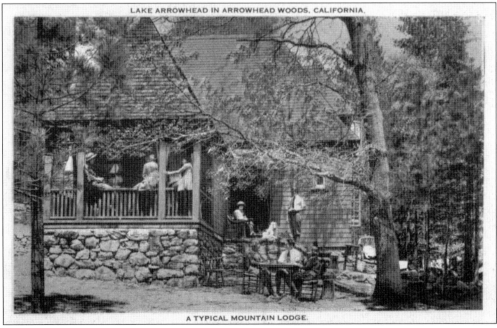

GUEST ACCOMMODATIONS, NORTH SHORE TAVERN. Comfortable guest accommodations were available at the Clubhouse or North Shore Tavern in small lodges and detached bungalows similar to the one depicted here. Guests could relax in a semi-informal atmosphere. Here the gentlemen have ties but wear no jackets. (CTA.)

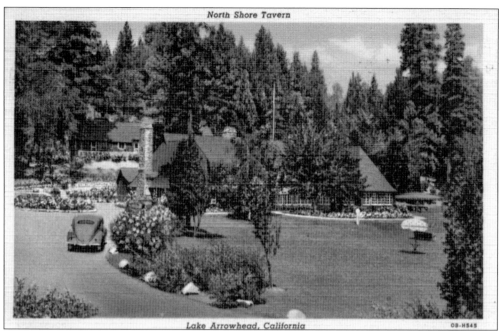

Lake Arrowhead, California

OB-HS45

TAVERN HEYDAY. This card was sold from the 1930s to the late 1950s. The back of this card reads, "North Shore Tavern, one of several fine hotels, is located on the exclusive North Shore—with private beach, tennis courts, and spacious grounds." In the late 1920s and early 1930s, this was reportedly the site of spirited Depression-era drinking, well out of sight of village visitors and children. (CC.)

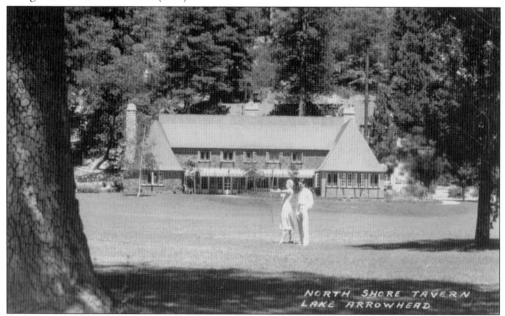

NORTH SHORE TAVERN. This view of the tavern, postmarked August 1932, contains a handwritten message reading, "Lake Arrowhead is glorious now—bring your Olympic visitors up here for a real treat." At the time this card was sent, the Los Angeles Olympics were nearing their end. (FI.)

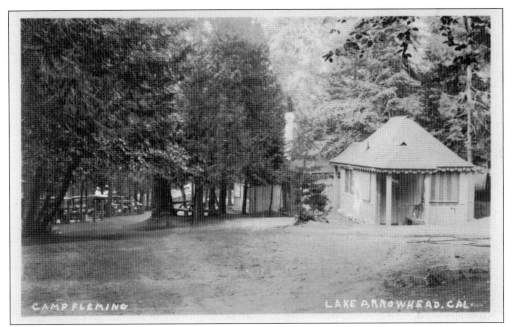

EARLY VIEW OF CAMP FLEMING. In 1922, an adventurous investor began building a camp so that frugal travelers could visit what was otherwise a very expensive place. Considered a counterpoint to the pricey adjacent village, Camp Fleming, with 40 cabins and 60 tent house sites, served for decades as the single largest Lake Arrowhead–area "budget" resort. This is an early real-photo view.

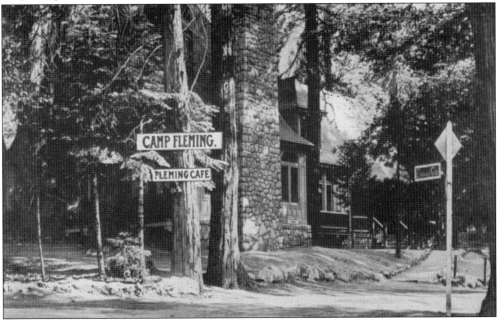

CAMP FLEMING IN "FLEMING GROVE." Owner R. S. Turner billed his camp as "America's Most Delightful Mountain Camp," offering bungalettes, canvas-covered cottages, and the Fleming Cafe. The camp also boasted, "No Snakes—No Poison Oak." A grocery store, which was added later, offered fresh vegetables, milk, butter, and all manner of grocery items.

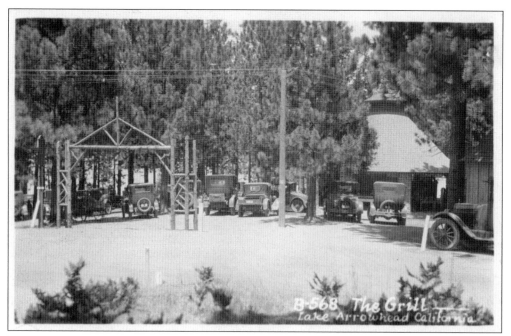

THE GRILL AT LAKE ARROWHEAD. The Grill was associated with a pay auto camp, where the occupants of each vehicle were given fishing privileges at the lake. The auto camp was electrified and had modern restrooms, designated cooking areas, and tap water. The Grill was situated about where Edgewater Shores is now located.

OPEN AIR GRILL. The handwritten message on this card says in part, "This is some beautiful spot. Drove up last night, wanted to bring Joyce up but she had cold feet. Never saw such scenery." The Grill was an open-air facility where customers could barbecue while protected from the elements.

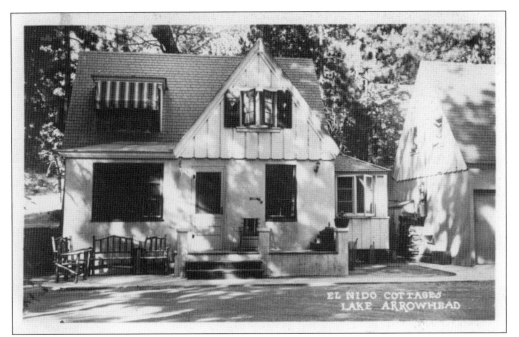

EL NIDO COTTAGES. These cottages were located just up from the village, away from the lake on Two Mile Road, in the location where the 7-Eleven is today. El Nido Cottages offered guests a prime location close to the entrance to the village and next door to the prestigious Raven Hotel.

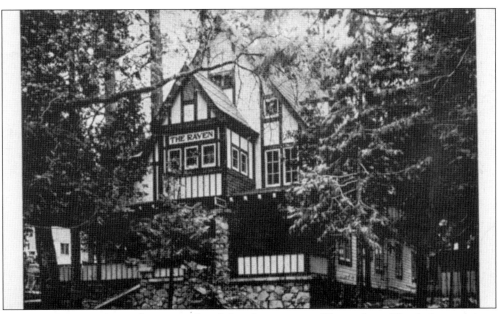

RAVEN HOTEL. An early promotional brochure states, "A modern Hotel, located in a beautiful shaded glen in Arrowhead Woods—just five minutes walk from the Lake and Village, convenient to all the sports. The Toboggan Slide passes the door." The 1924 Raven Hotel was remodeled in the 1980s and now houses the Raven's Nest at Lake Arrowhead Restaurant and Bar as well as the Saddleback Inn.

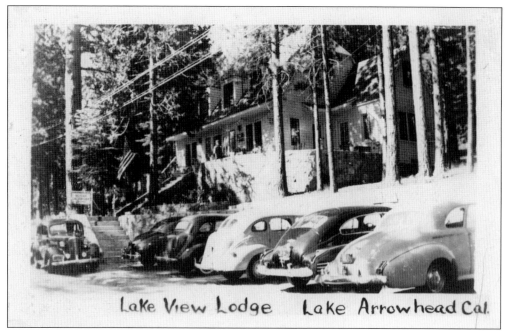

LAKE VIEW LODGE. Located on State Highway 189, the Lake View Lodge offered guests, not surprisingly, a room with a view of the lake. Seen in this mid-1940s image, the building has undergone various alterations over the years, and it now operates as the Lakeview Lodge "Romantique."

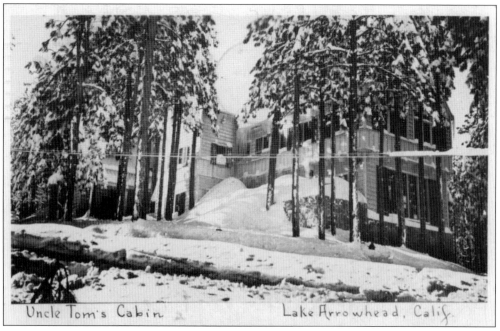

UNCLE TOM'S CABIN. Opened in the 1920s for duck hunters on Lake Arrowhead, this lodge became known as Uncle Tom's Cabin by the 1930s. This postcard mailed in June 1940 notes, "There is a MGM movie company up here." Uncle Tom's Cabin is located across from the entrance to the Lake Arrowhead Resort and is now known as the "Lodge at Lake Arrowhead."

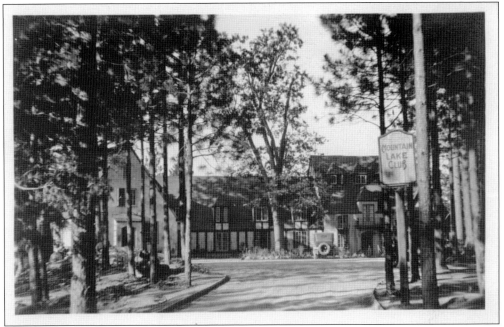

MOUNTAIN LAKE CLUB. Located adjacent to the village, this private club opened in the early 1920s. According to a brochure, it was a place "where men and women may escape to become . . . happy fugitives from the bondage of routine." The Mountain Lake Club had spacious rooms designed to appeal to even the most discriminating member.

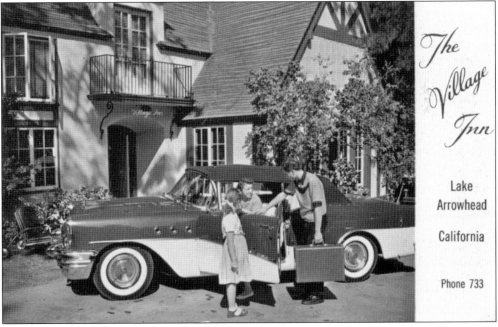

THE VILLAGE INN. By the mid-1920s, the private Mountain Lake Club's magnificent clubhouse was known as the Village Inn. Now open to the public, the inn was advertised as a restful, year-round resort close to all Lake Arrowhead social activities. This 1950s card is clearly posed. When was the last time a teenager helped his mother so happily? (CB.)

VILLAGE COTTAGES. Located just outside the entrance to the village, the Village Cottages offered 35 housekeeping cottages and a heated swimming pool. The back of the card reads, "The Village Cottages are in the heart of the Tyrolean Village—The center of all activity in the Lake Arrowhead area. (CK.)

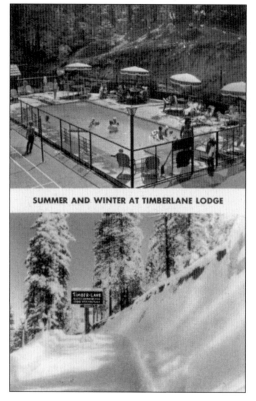

SUMMER AND WINTER AT TIMBERLANE LODGE

TIMBER-LANE LODGE. Located on Two Mile Road (now State Highway 173) about one-half mile from the village, the Timber-Lane Lodge (also called the Timberlane Cottages) featured a heated pool, a main lodge with fireplace, televisions, shuffleboard, a badminton court, ping-pong tables, and patios complete with barbecues. (FS.)

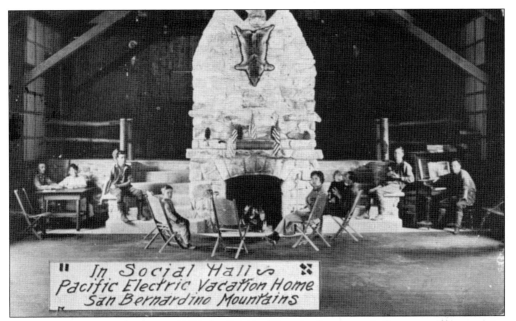

PACIFIC ELECTRIC CAMP. In 1917, the Pacific Electric Company built a vacation camp for its employees. Initially, the camp featured tent cabins, a large social hall with a massive rock fireplace (shown here), a campfire ring, and a swimming pool. The camp was located just east of Daley Canyon Road, to the south of Blue Jay, and immediately to the north of Agua Fria. Remains of the camp still exist today. (WP.)

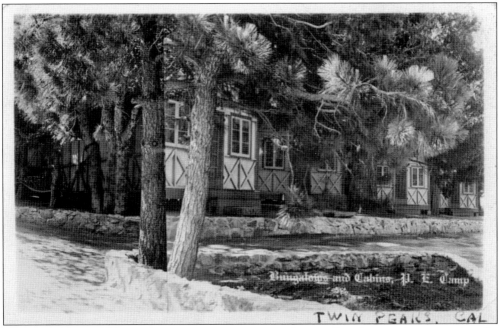

PACIFIC ELECTRIC BUNGALOWS AND CABINS. The Pacific Electric Camp continually expanded and improved its facilities. From 1917 to 1929, the camp was electrified, and permanent bungalows and cabins slowly replaced the original tents cabins. This card was sent in July 1929.

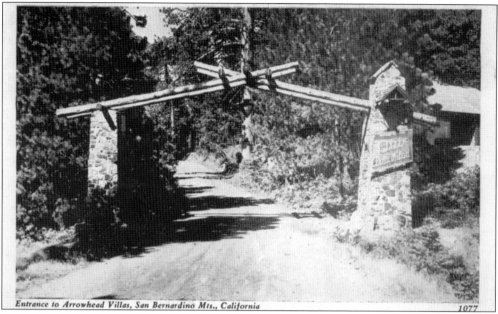

Entrance to Arrowhead Villas, San Bernardino Mts., California 1077

ENTRANCE TO ARROWHEAD VILLAS. This original entrance marked the way to the villas, just off of State Highway 18. Today the road is named Arrowhead Villa Road. The rock pillars still stand, but the sign reading "Club Arrowhead" and the over-the-road wooden structure are gone. The "club" was started in 1928, when $250 bought you a lifetime membership, a gold membership card, and all club privileges. (R.)

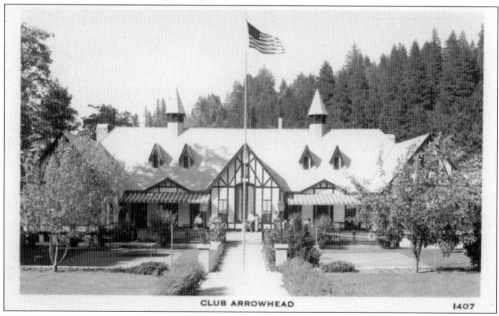

CLUB ARROWHEAD 1407

CLUB ARROWHEAD. In 1890, mountain pioneer Adam Kuffel's son was killed by a mountain lion. To raise money for the funeral, Kuffel sold the land on which this magnificent edifice was eventually built. The property was improved as it changed hands several times over the years, beginning in 1928 with the Atkins Development Corporation as part of a land development in the Arrowhead Villas, known then as Club Arrowhead of the Pines.

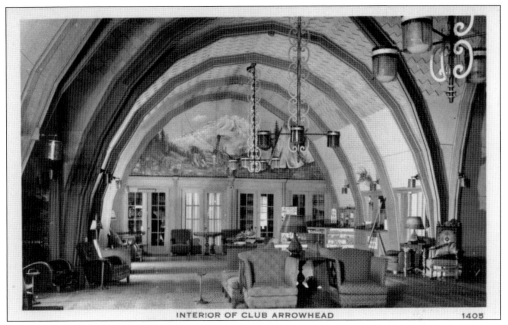

INTERIOR OF CLUB ARROWHEAD 1405

INTERIOR OF CLUB ARROWHEAD. Over the years, various owners have operated different businesses at this location—one of them was a restaurant known as the Lake Arrowhead Inn. The inn featured live entertainment nightly as well as seafood, sirloin, and spirits. The building still stands and has recently been used as a private residence.

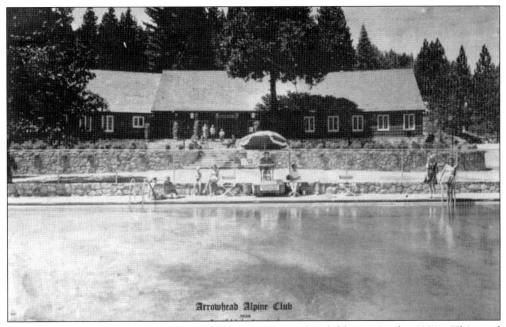

Arrowhead Alpine Club

ARROWHEAD ALPINE CLUB. Construction began on the clubhouse in the 1930s. This card was sent in July 1942, and the writer notes, "Air Patrol flies over daily." Club guests reportedly included such luminaries as Betty Grable, Jane Russell, Fred Astaire, Bette Davis, Clark Gable, June Lockhart, Joan Crawford, Lana Turner, and Shirley Temple.

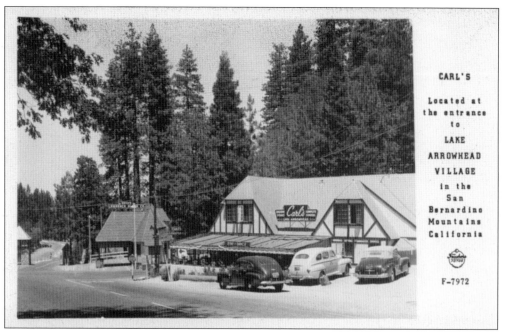

CARL'S RESTAURANT. Carl's was located at the entrance to the village. This vintage real-photo postcard from the 1950s is often seen today at postcard shows. In later years, the building burned and was rebuilt, opening first as The Gay 90's and later as a Kentucky Fried Chicken. Part of the building is now a real estate office, and the former restaurant portion is currently vacant. (FI.)

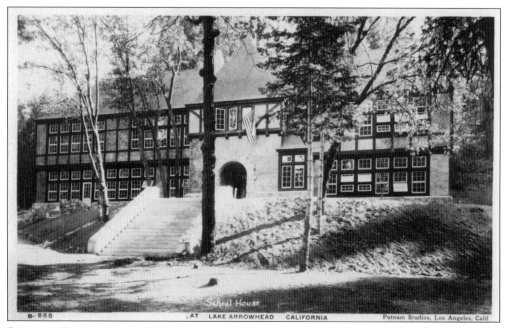

SCHOOL HOUSE, LAKE ARROWHEAD. In September 1926, the new schoolhouse in Lake Arrowhead opened. The building now houses Lake Arrowhead Fire Station No. 91. Mountain pioneer Mary Putnam Henck was instrumental in the establishment of the school. Before the construction of the schoolhouse, she taught children in a small building in the village. (PS.)

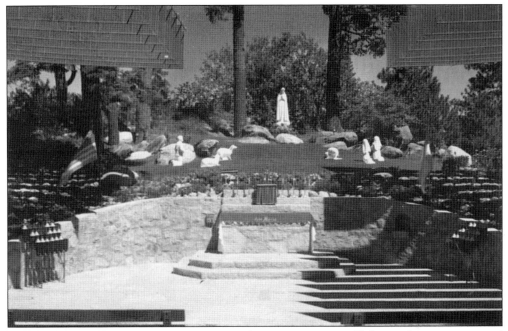

OUR LADY OF FATIMA SHRINE. This complete Fatima group of life-size figures was carved by sculptor Senhor Jose Thedim from white Portuguese marble. The shrine was dedicated in 1953 and was then the only one of its kind in America. The inspiring outdoor chapel near Lake Arrowhead is visited annually by thousands. (WRP.)

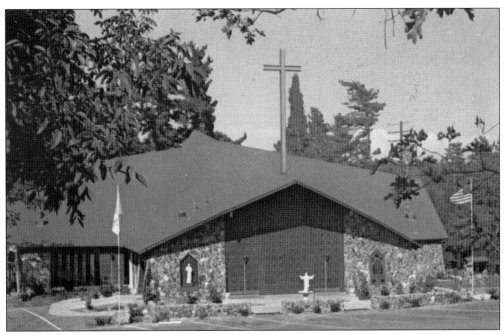

OUR LADY OF THE LAKE. This Catholic Church was built in a cruciform plan. Its walls of glass overlook the Fatima Shrine. Work started on the church on September 19, 1973, and the church officially opened on March 19, 1974. (SH.)

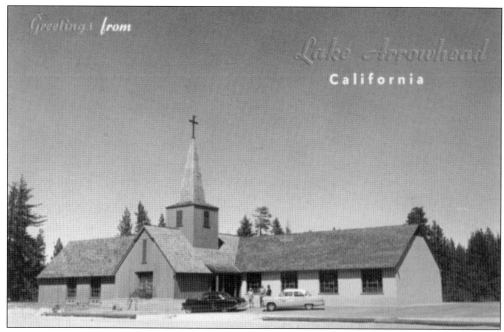

LAKE ARROWHEAD COMMUNITY CHURCH. The Los Angeles Turf Club, upon acquiring the Lake Arrowhead properties in 1946, donated the land on which this Presbyterian church was built. Noted African American architect Paul Revere Williams created this picturesque chapel. Local resident and member of the pioneering Henck family, J. Putnam Henck served as the contractor. The first service was celebrated here on April 22, 1951. (WRP.)

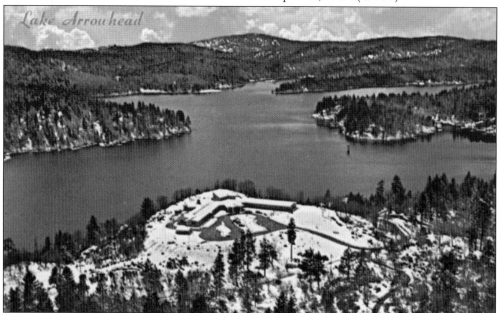

SANTA ANITA HOSPITAL. The Los Angeles Turf Club gift of the Santa Anita Hospital, first owned and operated by the Sisters of St. Joseph of Orange, marked a new era in health care for residents of the San Bernardino Mountains. The hospital, located on a bluff overlooking the lake, opened in 1951 with 24-hour service—a mountain first. (WRP.)

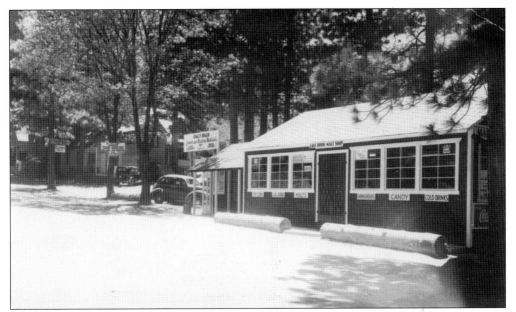

LAKE BROOK MALT SHOP. Cedar Glen is a small community near the east shore of Lake Arrowhead. In 1916, lumberman John Suvurkrup subdivided land and began selling lots here for $150 each. An early real estate development in the Cedar Glen area was called Lakebrook or Lakebrook Park. The Lake Brook Malt Shop is shown here. Today it is the Cedar Glen Malt Shop. (R.)

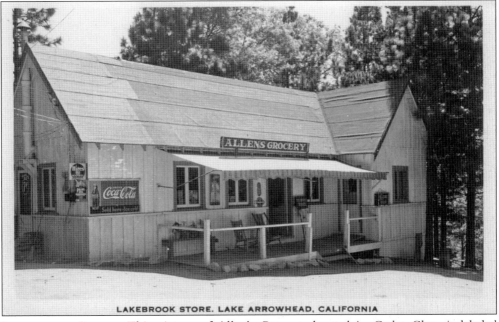

LAKEBROOK STORE. This picture of Allen's Grocery, located in Cedar Glen, is labeled "Lakebrook Store, Lake Arrowhead, California." The store sold all sorts of useful items according to signs on the outside of the building advertising the following items: Fresh Up Seven-Up, "Ice Cold" Coca-Cola, Hires R-J Root Beer, Pearl Oil Kerosene, Wheaties, AGFA Film, Oxydol, the *Los Angeles Times*, and, of course, Acme Beer. (R.)

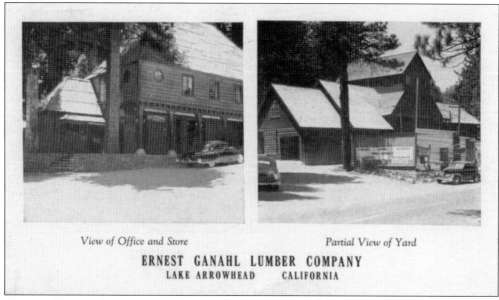

View of Office and Store Partial View of Yard

ERNEST GANAHL LUMBER COMPANY
LAKE ARROWHEAD CALIFORNIA

ERNEST GANAHL LUMBER COMPANY. Advertising postcards were issued by many commercial enterprises. Here is one from the Lake Arrowhead area printed for Ganahl Lumber. Located on State Highway 189 between Blue Jay and the village, the lumberyard burned to the ground in 1986. The owners quickly announced that the lumberyard would be rebuilt, but the property remains vacant to this day.

MISIDENTIFIED LAKE ARROWHEAD. At Lake Arrowhead, the trees are deep green, the baby blue sky has a scattering of cotton-ball white clouds, and the lake is a deep, rich blue. What is wrong with this image? Well, it's *not* Lake Arrowhead! A common practice in the postcard business was to slap several different place names on the same image. This picture is actually of Lake Gregory. (WRP.)

Five

ACTIVITIES AT THE LAKE

Lake Arrowhead investors, architects, and planners sought to create, among other things, a recreational destination. They single-mindedly strove to develop a world-class resort with a multitude of activities for fun and enjoyment. The equation was quite simple. Activities equaled fun, and fun equaled happy visitors, which equaled more visitors—all adding up to profit. It was a great plan.

A 1920s Lake Arrowhead promotional brochure ballyhoos Lake Arrowhead as "California's Finest Playground—Where days are longer, sports are keener and sleep is sweeter." It concludes that Lake Arrowhead is a "mountain lake resort that is unique, not alone in Southern California, but throughout the entire west."

A few years later, a 1930s promotional brochure focuses on Lake Arrowhead as a "year round playground . . . [where] whatever the season visitors find mile-high Lake Arrowhead holds for them a wealth of pleasure—be it swimming in turquoise waters, boating, fishing, or enjoying thrilling water sports in a sparkling snow-covered world. Nature provides a scenic treat in each distinctive season, from the glorious beginning of spring, through sun-drenched summertime, to the colorful, 'Indian Summer' of fall—and finally the mystical snow-mantled months of winter." The same brochure lists activities at Lake Arrowhead as including a nine-hole championship golf course, horseback riding with barbecues and breakfast rides, the glorious freedom of lake swimming with lifeguard protection, tennis, boating with row and motor boat rentals, yacht races and regattas, dancing, theater and orchestras, skiing, skating, tobogganing, and sledding.

By the 1950s, one brochure simply states, "If you haven't yet visited beautiful Lake Arrowhead, be sure to plan a holiday here just as soon as you can. Fine hotels, motels, and cottages are pleasantly situated nearby, with excellent restaurants and a wide variety of entertainment for your enjoyment year 'round. You'll have a wonderful time."

Lake Arrowhead in the golden years really did have it all, and the following postcard images from the early 1920s to the end of the 1950s prove it beyond all doubt.

LAKE ARROWHEAD ACTIVITIES IN 1922. Mailed in September 1922, the message reads, "It is beautiful. We had a wonderful drive around the lake this morning." The village was not yet complete, the luxurious Arlington Lodge had not yet opened, and there really wasn't much to do but drive or walk around the lake and bask in the natural beauty. That would soon change.

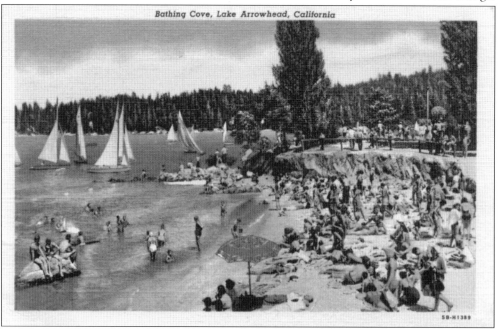

LAKE ARROWHEAD ACTIVITIES IN 1952. This card was mailed in June 1952. Compare this to the card above. Pictures really are worth a thousand words. Lake Arrowhead was absolutely packed with vacationers—homeowners and tourists alike—from Memorial Day until Labor Day, with the rest of the year filled with weekenders and winter enthusiasts. (CC.)

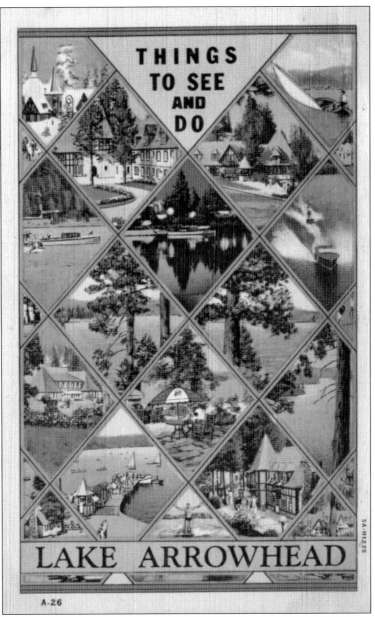

THINGS TO SEE AND DO. This card appears in different formats from the mid-1930s to the early 1950s. It first appears in the mid-1930s as a colorful linen, then as a white-border, black-and-white printed image, and finally as a real-photo postcard in the mid-1950s. Varying captions appear on the back. One of the most popular cards ever printed, it is particularly well designed and artistically presented. It shows just about every activity (or activity area) possible at Lake Arrowhead, including (from the top left) winter activities, a luxury hotel, shops, sailing, horseback riding, the beach, motorboating, the harbor at night, water skiing, a scenic view of the lake through the trees, golf, the North Shore Tavern, al fresco dining on stone patios, fishing, boat-excursion tours, wakeboarding, more shopping, and a movie theatre. Incredibly, most of the mid-1930s activities depicted on this postcard are still available to Lake Arrowhead homeowners today. (CC.)

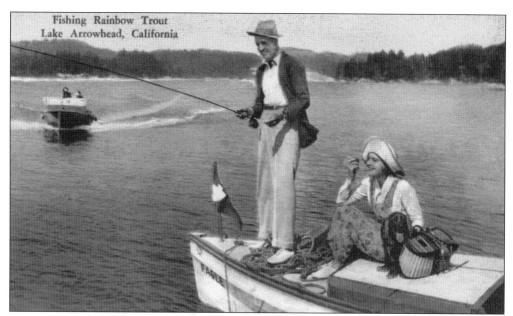

Fishing Rainbow Trout
Lake Arrowhead, California

"LURE" OF FISHING AND ROMANCE. This hand-colored, posed postcard was printed about 1930. It is highly evocative of promised romance, adventure, and the lure of nature. The back reads, "Lake Arrowhead, via the new High Gear Scenic Highway, offers the utmost in recreational advantages." Fishing, a carryover from the Little Bear Lake era, was the first genuine Lake Arrowhead recreational activity. (TAC.)

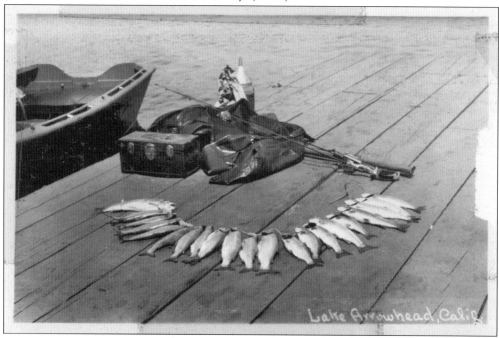

CATCHING THE LIMIT. In the early days, catching your legal limit while fishing at Lake Arrowhead was common. This 1940s view shows a single-day limit on a stringer, an outboard motor in a rubberized bag, two rods, and a glass jar of gasoline with a funnel. A serviceable and heavily built wooden rental boat is tied to the dock. Oars were provided as a backup.

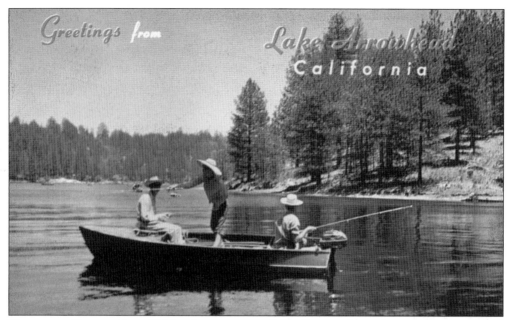

FISHING IS FAMILY FUN. Fishing boats were available for rent throughout the 1950s and had been a part of Little Bear/Lake Arrowhead history since at least 1915. The original heavily built rental boats were replaced with somewhat sleeker versions, but the basic idea remained the same. The back of the card reads, "The lake is plentifully stocked with trout, bluegill and other varieties of fish." (WRP.)

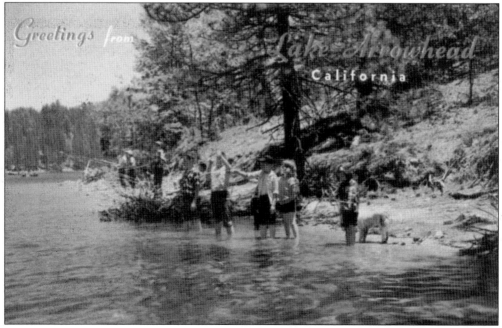

PINE-CLAD SHORES. The back of this 1950s card reads, "Here the fishing is good and water sports are unexcelled. The sparkling blue waters surrounded by Pine clad shores, afford rest or play, day or night in a setting of incomparable charm." In the good old days, there were many places around the lake where the general public could simply toss in a line. (WRP.)

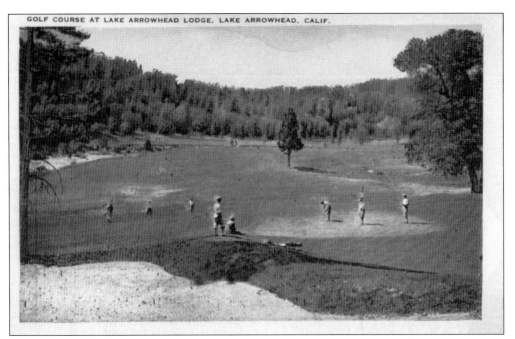

GOLF COURSE AT LAKE ARROWHEAD LODGE, LAKE ARROWHEAD, CALIF.

GOLF AT LAKE ARROWHEAD. This is perhaps the earliest view of golf being played in the San Bernardino Mountains. This mid-1920s postcard shows players on what was originally billed on the front of the card as the "Golf Course at Lake Arrowhead Lodge, Lake Arrowhead, California." The golf course was built on land once occupied by the historic Tyler Lumber Mill. (BRM.)

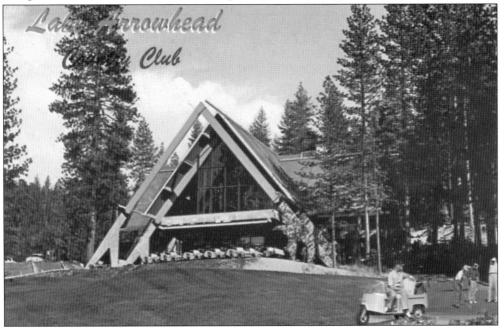

THE COUNTRY CLUB. What started as a golf course attached to the Lake Arrowhead Lodge is now known as the Lake Arrowhead Country Club. The back of this chrome postcard reads, "This popular country club over a mile high in the San Bernardino Mountains can well be proud of its picturesque club house [new when the photo was taken] and beautiful fairways." (WRP.)

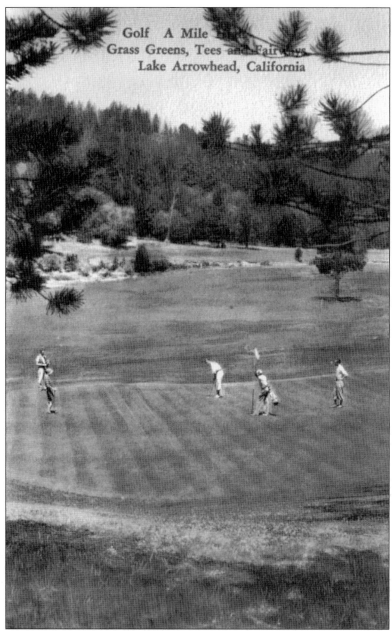

Golf A Mile
Grass Greens, Tees and Fairways
Lake Arrowhead, California

GOLF A MILE HIGH. This hand-colored 1930s postcard advertises grass greens, tees, and fairways. A popular Lake Arrowhead lure was that one could golf "A Mile High." In the 1920s and 1930s, golf was regarded as a sport of the privileged, and the backers and promoters of Lake Arrowhead sought to attract wealthy buyers by continually improving the golfing facilities. After one upgrade, a 1930s brochure proudly proclaimed that there was "a new zest to golf on Lake Arrowhead's sporty nine-hole championship golf course. Club house; professional in attendance. Thrilling matches and exhibitions." As early as 1925, a California guidebook places golf near the top of the list of activities, describing Lake Arrowhead as follows: "Around its shores is an extensive summer colony including many privately owned cottages, the Arrowhead Club and Golf Links, and on the S. shore the Village." (TAC.)

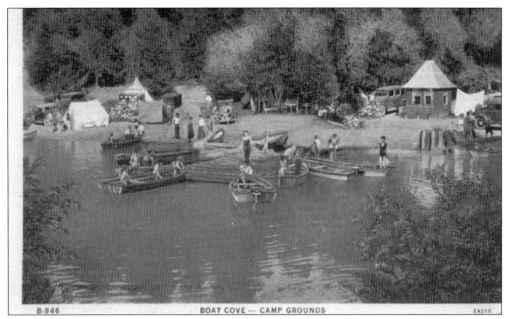

Boat Cove, Camp Grounds. Campgrounds at Lake Arrowhead provided a convenient destination point for the automobilist. In the 1920s and 1930s, more than two-thirds of all vacationers chose camping rather than staying in expensive hotels. Most Americans were thrifty, and the idea of sleeping outdoors still had considerable appeal to those removed by only a single generation from those who traveled across the country by wagon train. (PS.)

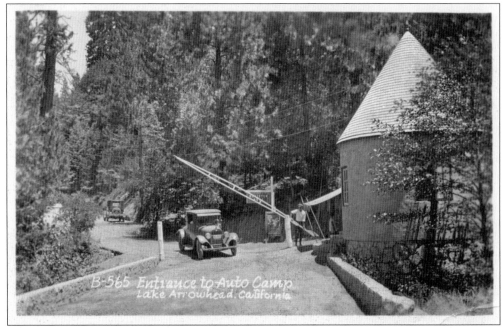

Entrance to Auto Camp. Postmarked Lake Arrowhead on July 14, 1928, this card reads, "Dear G. We are up here camping for a few days, and are having a wonderful time. Harold & G. are with us. Lovingly, Lottie." The printing on the front of the card reads, "Entrance to Auto Camp, Lake Arrowhead, California."

CAMPING AND PICNIC GROUNDS. The postcard above depicts an impromptu boat launch about 1941. It is an early color print, published in 1941 by the Union Oil Company of California. At that time, one could literally drive his or her car onto the shoreline to launch a boat. The back of the card reads, "Lake Arrowhead, one of Southern California's most popular mountain resorts, is a mile-high, man made lake filled by natural springs. Here swimming, boating, fishing, and camping are within easy high-gear driving distance from Los Angeles." The card below shows the same camping/picnic grounds in the 1950s. Sent in June 1958 to Ann in Santa Monica, it reads, "Will be here at least a week or ten days. Weather lovely & bracing." (Above UOC.; below CC.)

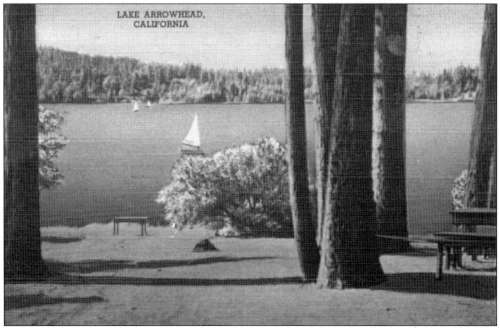

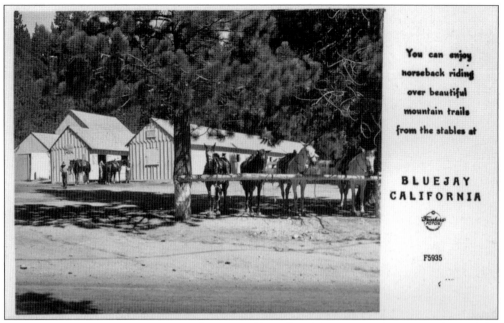

You can enjoy
horseback riding
over beautiful
mountain trails
from the stables at

BLUEJAY
CALIFORNIA

F5935

HORSEBACK AROUND THE LAKE. Blue Jay Stables offered inexpensive horse rentals until the 1960s. Anyone and everyone could take a compliant horse for a spin around the bridal path, which girded the shores of Lake Arrowhead. Interestingly, public access to the entire lakeshore was a part of the original development concept, and horseback riding was one of the most popular attractions. For a period of time, mules were also available. The image above shows the rustic stable where one could begin to "enjoy horseback riding over beautiful mountain trails." The image below is a limited edition real photo of spring sunlight filtering through the newly blossomed trees. Boys and girls are seen here in the late 1940s or early 1950s, and one of the boys sports a spiffy crew cut. (Above FI.)

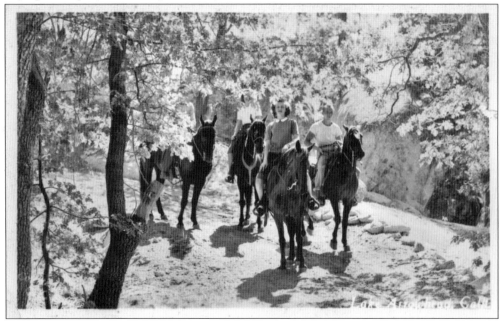

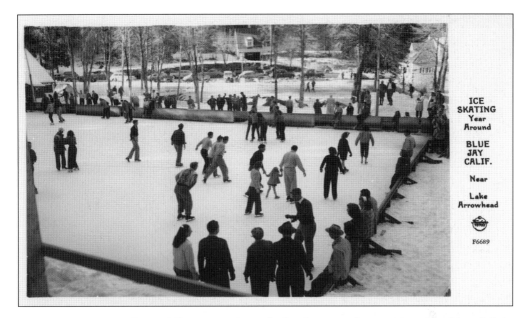

THE BLUE JAY ICE RINK. These two views depict the once-famous year-round ice rink in Blue Jay. An early seasonal ice rink was first built in Blue Jay in the 1930s, but by the 1940s, it had become a year-round phenomenon. Unique to Southern California, one could ice skate in an alpine setting during the heat of summer, covered only by a canvas roof. The attraction was almost magnetic, and this site would eventually become the location of the world-famous Ice Castle. The mid-1940s view above shows patrons of all ages. Several members of the younger generation are clearly on a date. The rink was, in fact, a popular gathering place for over 50 years. Taken slightly earlier, the summer view below shows the open construction of the facility. (Above FI.)

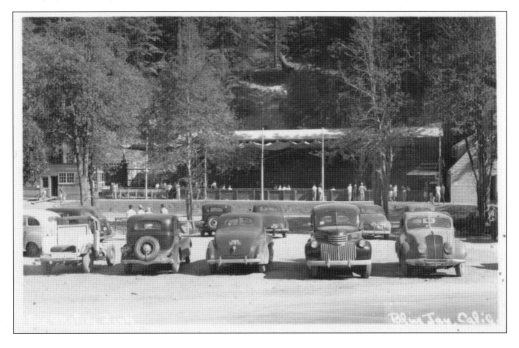

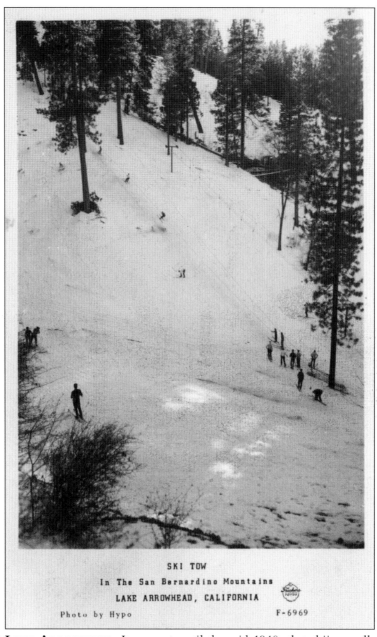

SKI TOW

In The San Bernardino Mountains

LAKE ARROWHEAD, CALIFORNIA

Photo by Hypo F-6969

SKIING AT LAKE ARROWHEAD. It was not until the mid–1940s that skiing really took off in the San Bernardino Mountains. A post–World War II boom resulted in the development of an extensive array of facilities in the both the San Bernardino and San Gabriel Mountains. By the early 1950s, one authority concluded there were more skiers per capita in southern California than any other place in the United States. At this time, tow lifts were operating in Green Valley, Snow Valley, and Big Bear. One brochure notes, "Every week end when there is snow on the slopes, you will see the highways leading to the Rim O' World Drive crowded with cars bearing skis and toboggans." This view shows a "ski tow" or rope tow, one of the earliest mechanical methods of reaching the start of the run, whereby the skier simply held onto a powered rope that ran in a continuous loop up and down the hill. (FI.)

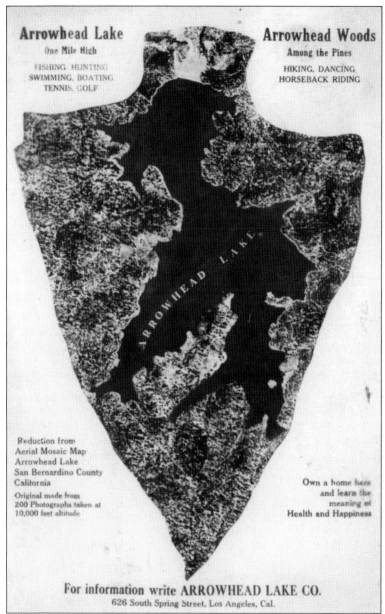

Arrowhead Lake
One Mile High

FISHING, HUNTING,
SWIMMING, BOATING
TENNIS, GOLF

Arrowhead Woods
Among the Pines

HIKING, DANCING,
HORSEBACK RIDING

ARROWHEAD LAKE

Reduction from
Aerial Mosaic Map
Arrowhead Lake
San Bernardino County
California

Original made from
200 Photographs taken at
10,000 feet altitude

Own a home here
and learn the
meaning of
Health and Happiness

For information write ARROWHEAD LAKE CO.
626 South Spring Street, Los Angeles, Cal.

LAKE ARROWHEAD MOSAIC. This is a great view of the entire lake and an advertisement for the many activities there. This promotional card was mass produced by the Arrowhead Lake Company, backers of the Arrowhead Woods project. The firm was headquartered on Spring Street in Los Angeles. Their aim was to sell as much real estate as possible by proclaiming, "Own a home here and learn the meaning of health and happiness." Unfortunately, the Depression and World War II threw a curve into their well-laid plans. In 1946, bankruptcy forced the sale of all of the Arrowhead Woods properties to the Los Angeles Turf Club. The view on this card is actually an aerial mosaic map, assembled from 200 individual photographs taken at an altitude of 10,000 feet. These cards were distributed free to all who entered the real estate offices of the Arrowhead Lake Company. Surprisingly, it is not as common an item as one might think in the collector marketplace. Many have likely been thrown away.

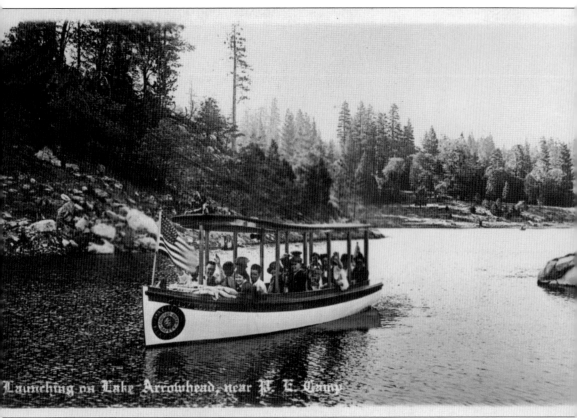

Launching on Lake Arrowhead, near P. E. Camp

LADY LOUISE ON LAKE ARROWHEAD. This rare close-up view depicts one of the launches and ferries that have plied the waters of Lake Arrowhead from the early 1920s to the present. Today people enjoy the *Arrowhead Queen* (actually there have been several of them). In years past, Lake Arrowhead has also boasted the *Blue Jay* and the *Lady Louise*, sister ships that ferried passengers for decades to various destinations around the lake. The caption on this postcard reads, "Launching on Lake Arrowhead, near P.E. Camp." The Pacific Electric Camp, an employee-recreation facility established about 1917, was located in Agua Fria (at the site of the big stone chimney on the east side of Highway 189, adjacent to Little Bear Creek). At this time, the *Lady Louise* appears to have been used exclusively by the camp, as the painted circle on the bow reads, "Pacific Electric: Comfort, Speed, Safety."

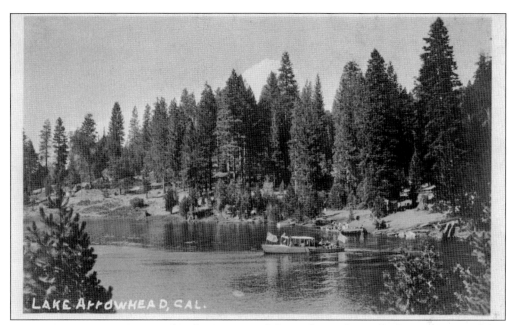

EARLY EXCURSION BOAT. This depicts one of the earliest, if not the first, excursion boats on Lake Arrowhead. It was quite primitive in comparison to later designs, but the boat is portrayed on various postcards in almost every location at the lake, including the Clubhouse, the public campground, and the main dock at the village.

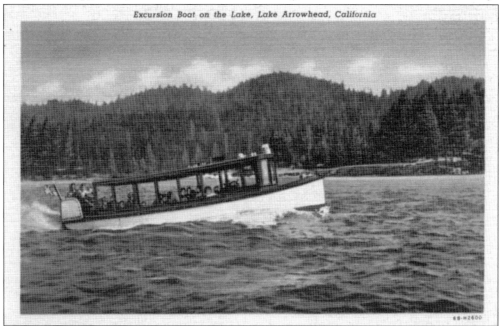

LAKE FERRY. The *Blue Jay*, a sister ship to the *Lady Louise* and one of two nearly identical excursion boats that plied the waters of Lake Arrowhead for decades, is shown here. Holding more passengers in greater comfort than the early excursion boat shown above, the last boat, the *Blue Jay*, was taken out of service when it sank at the dock (due to rotten planks) shortly after delivering a final load of passengers. (CC.)

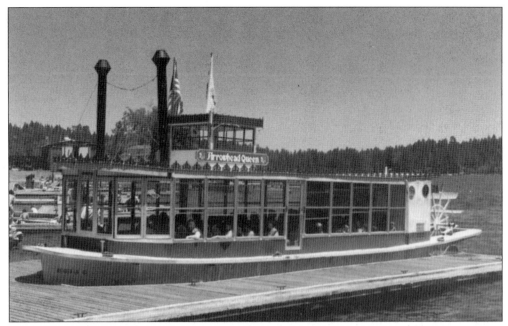

LAKE ARROWHEAD QUEEN. Today's *Arrowhead Queen* began life as a houseboat and was converted to her present use. The "Queen" has been remodeled several times. The two views shown here depict the craft in various incarnations. In the mid–1920s, a tour around the lake cost a total of 25¢. Times have since changed, as have the boat and the prices, but the attraction is the same. A tour around Lake Arrowhead gives one an up-close glimpse of the lifestyle of the leisure class. Tour riders don't have to rent a boat (actually more costly than the tour itself), start a gasoline engine (and perhaps row back if the engine suddenly quits), or try to figure out what they are looking at. A trip on the "Queen" has always been a bargain. (Above DC.; below WRP.)

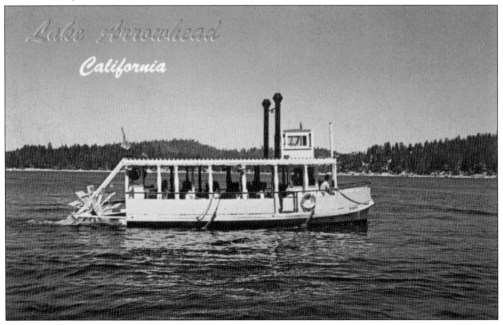

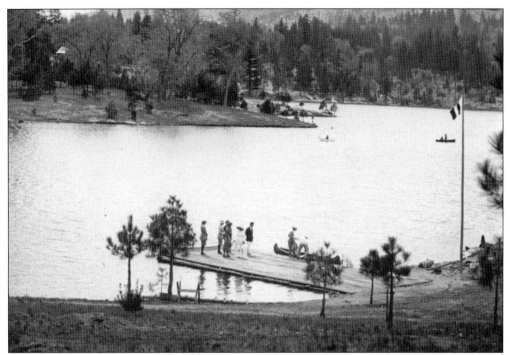

THE LANDINGS. The above 1923 view shows the boat landing at the Clubhouse as built beginning in 1921. This was a place where prospective buyers were wined and dined. Soon renamed the North Shore Tavern, it is now the location of the UCLA Conference Center. The view below, taken in the mid-1950s, is of the main Lake Arrowhead dock. The sign reads, "Village Boat Landing—Boat Rentals—Excursion and Speedboat Trips." Here one could rent a guided excursion tour around the lake, a speedboat ride (probably in a Chris–Craft), rowboats, sailboats, small "putt–putt" motorboats, and all of the associated paraphernalia. (Below RP.)

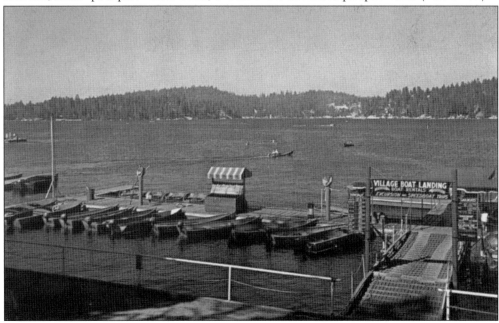

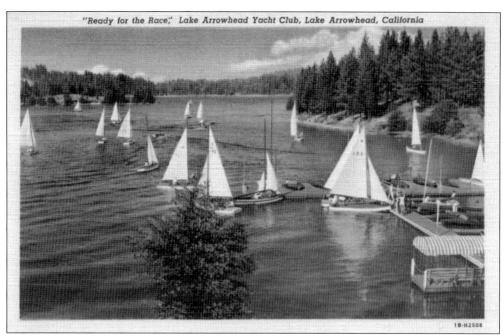

"Ready for the Race," Lake Arrowhead Yacht Club, Lake Arrowhead, California

READY FOR THE RACE. The Lake Arrowhead Yacht Club has a prestigious history. The back of the card reads, "Numbers of trim sail boats skim over the shimmering waters of Lake Arrowhead, and many colorful and exciting racing events are staged during the vacation months." Edi Jaun organized the club during the 1930s, seeming evidence that Lake Arrowhead was virtually Depression-proof. (CC.)

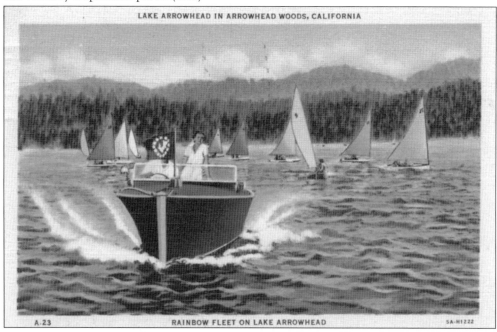

LAKE ARROWHEAD IN ARROWHEAD WOODS, CALIFORNIA

RAINBOW FLEET ON LAKE ARROWHEAD

THE RAINBOW FLEET. This 1940s view depicts a yacht race. The novelty of being a yacht-club member at a mile-high mountain resort must have appealed to many. The sailboats are from the historic Rainbow Fleet. Note also that the motorboat shown is a Woodie. (CC.)

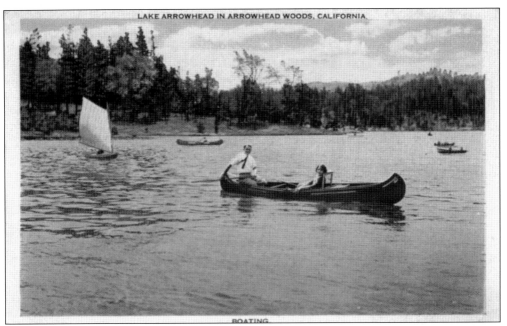

BOATING

ROMANTIC CANOE RIDES. Here, in an obviously posed view, a young man paddles his sweetheart along the shoreline of Lake Arrowhead. Leaning on a backrest, her hand is poised to trail in the cool blue waters of the lake. From the 1920s to the 1950s, canoes enchanted travelers in search of true love. (CC.)

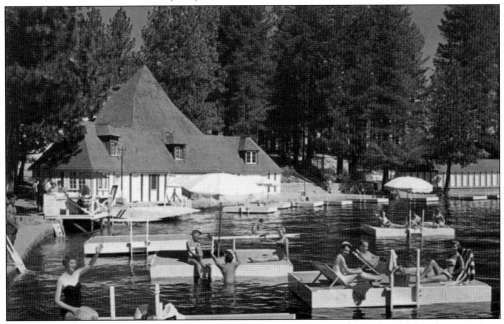

HARBOR SUN FLOATS. These were a popular harbor attraction. The postwar years were relaxed and happy ones. Here, the veteran, the factory worker, and the housewife could bask on the harbor sun floats like movie stars. Postcards record several different versions of the floats, including those with umbrellas, tables, and chairs. One simply walked or swam from the seawall to the float under lifeguard supervision. (CB.)

103

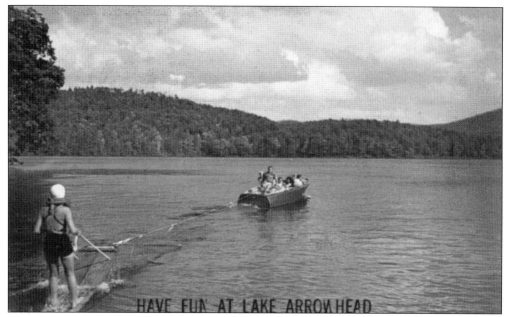

WAKEBOARDING. This is a great action postcard of a wakeboard being towed behind a speedboat in the mid-1950s. Wakeboards are depicted in Lake Arrowhead brochures as early as the 1930s. This card shows a rather overloaded Woodie and one of the greatest ways to "Have Fun At Lake Arrowhead." (DPI.)

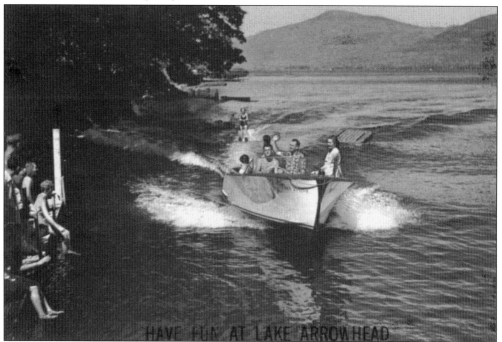

WATER-SKIING IN STYLE. For some five decades Lake Arrowhead boasted a water-ski school of world-class quality. Apart from fishing, water-skiing was perhaps the most popular lake activity. This mid-1950s view is great, but it isn't of Lake Arrowhead, despite what the printed label says. A magnifying glass reveals that the boat has a New York registration. (DPI.)

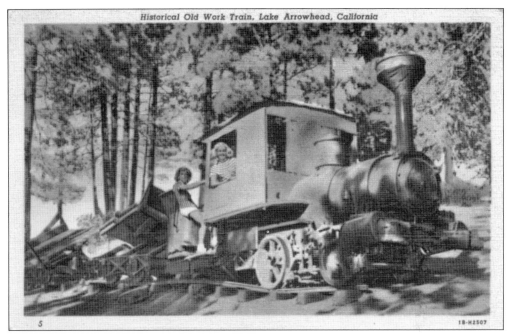

BLACK ANNIE. This card depicts "Black Annie," one of several work-train steam engines used in the construction of the Lake Arrowhead dam beginning in 1904. The engine was, for a number of years, a tourist attraction at Lake Arrowhead. Long thought to be at the bottom of the lake, it was recently identified as being on display in a Nevada museum. (CC.)

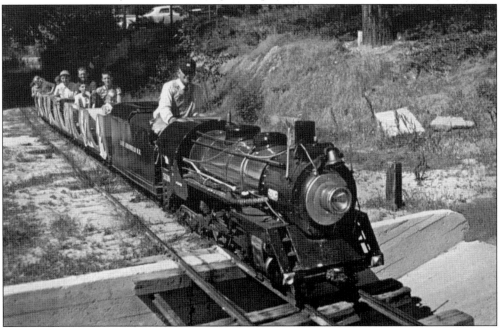

A REAL TRAIN RIDE. This scale model train delighted children and adults alike as it chugged along the shores of Lake Arrowhead in the village. The top speed was 14 miles an hour with a 120-pound head of steam. Later converted to gasoline power, the engine was built at a scale of two inches to the foot. (RP.)

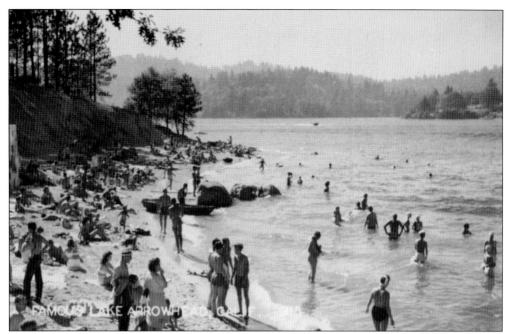

A Busy Day at the Beach. The beach at Lake Arrowhead was extraordinarily crowded on a holiday weekend. This early 1950s view was clearly taken at such a time. The beachwear depicted is amazingly varied. One man is completely dressed, including a straw hat. Some women are wearing two-piece bathing suits, but the one-piece is still the most popular. Most boys have crew cuts and trunks.

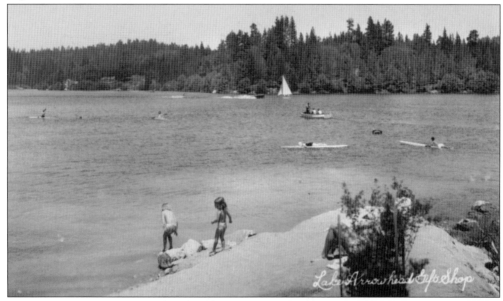

Kids at the Beach. For decades, the most popular attraction for children visiting Lake Arrowhead was the beach. Sandcastles could be built and toes could be dipped in the cool clear waters in a safe environment. This late-1940s view depicts two adorable children (perhaps a brother and sister) and an amazing amount of activity in the background, including speedboats, sailboats, kayaks, and paddle boards.

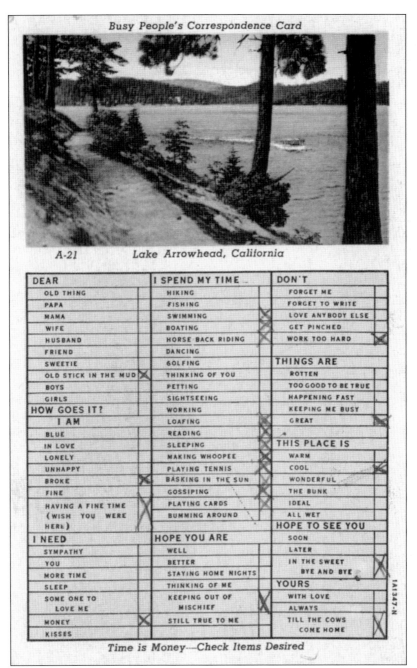

CORRESPONDENCE CARD. Various versions of this card were printed for hundreds of locations across the country. Rather than write on the back, one simply checked off boxes. When reading the checked boxes in order, this card says, "Dear old stick in the mud. I am broke. Having a fine time. Wish you were here. I need money. I spend my time swimming, boating, horseback riding, loafing, reading, sleeping, making whoopee, playing tennis, basking in the sun, gossiping, and playing cards. Hope you are keeping out of mischief. Don't work too hard. Things are great. This place is cool. Hope to see you in the sweet bye and bye. Yours, till the cows come home." It was sent by Linda in June 1953 to Philip in Pomona, California. (CC.)

MODELS LOAF IN STYLE. First published in the late 1950s, this card truly defines what the word "vacation" meant at Lake Arrowhead. In a strange way, perhaps the biggest attraction at Lake Arrowhead—and one continually referred to by writers of postcards from the 1920s to the present—wasn't really an activity at all. It was, in fact, quite the opposite. Lake Arrowhead was so different from the city that here one could simply do nothing and be revitalized just by soaking up the ambiance. The back of this card reads, "This view from the Lodge Terrace is one of the most picturesque in the west." The posed models in this picture are simply loafing, perhaps the best activity of all. (WRP.)

Six

THE MOST BEAUTIFUL PLACE I'VE EVER SEEN

Postcard images can be rare and evocative, but it's the message on the back that often has the most powerful and lasting impact. The mostly handwritten messages are like time capsules, bringing alive specific moments in time and capturing thoughts that may be intimate, funny, observant, speculative, informative, or reminiscent.

Superlatives appear to be the watchwords when writing postcards. Simple words such as wonderful, beautiful, pretty, delightful, and lovely are not overly descriptive on their own. However, when combined with a few additional adjectives and adverbs, the result is genuinely magical.

Writers of postcards repeatedly describe Lake Arrowhead as a "mile high wonderland," the "most wonderful" place where one may have "a perfect time playing," amid "the most wonderful trees in the world" with "the most marvelous view" of the "most beautiful place I've ever seen." The valedictories are also quite touching, frequently expressing "heaps of love," a "wish that you were here with us," or a "wish you could spend a few days here."

In effect, postcards distill the thoughts of the writer by providing a very limited amount of space in which to write. Here the thoughts, dreams, and reflections of those long gone or long forgotten are brought back to life.

For all those interested in the personal side of history, these reflections are of untold value. With truly humorous intent, it may be said that they provide the most "delightful" view of a "pretty place" and of the "wonderful" people that chose to live, visit, and vacation in "the most beautiful place in the world!" Enjoy this peek into the private lives of those who have visited and loved Lake Arrowhead through the years.

VIEW FROM BATHING COVE POINT. Sent on October 7, 1946, to San Diego, this card reads, "Dear Mama, I spent today here swimming and did enjoy it. *It is the most beautiful place I've ever seen.* We took pictures which I'll send when they come back. Love Deb." This card epitomizes many of the sentiments that appear on literally hundreds of thousands of postcards sent from Lake Arrowhead. (CC.)

LAKE ARROWHEAD IN ARROWHEAD WOODS, CALIFORNIA

A LAKE ARROWHEAD RESIDENCE

LAKE ARROWHEAD RESIDENCE. This promotional card reads, "Make your vacation a time of pure delight in this mile high wonderland. Golf, swim, motor boating; everything to make the vacationist happy. Lake Arrowhead for happy children, for busy fathers and careful mothers. You will enjoy it all." It was sent in 1928 to a Dr. G. in Los Angeles. (PS.)

AUTUMN VIEW. This card was sent to a doctor in Los Angeles in 1934. The message reads, "Dear Uncle, We are having a perfect time playing. I am being a first class bum—The altitude hasn't affected me much. . . . See you soon—Wish you could spend a few days here—it's grand. A. J." Lake Arrowhead is truly a superlative kind of place. (PS.)

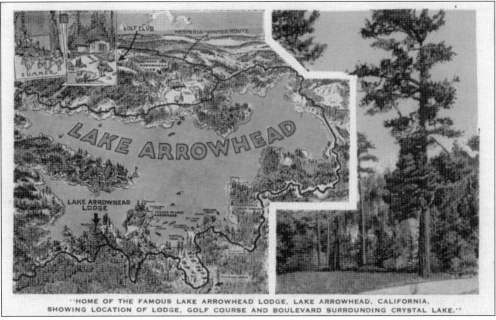

LAKE ARROWHEAD MAP. Postmarked 1945, this card reads, "Hi: Here is your card. Now make sure and save it. This place is really beautiful. I feel like getting lost in these mountains. . . . But of course I don't want to get lost alone. This place does things to you. Love J." Clearly a teenage daughter is writing to her parents, trying desperately to annoy them. Some things just don't change. (BRM.)

LAKE ARROWHEAD, CAL.

A "Wonderful" View. Cards frequently refer to Lake Arrowhead as a "wonderland." Sent in 1923 to Long Beach, this one reads, "Had a most delightful trip over the Rim of the World thru rugged mountain scenery. This is a great place for a vacation—a real wonderland. We are located at Camp Fleming in a house keeping tent. You must see this place sometime."

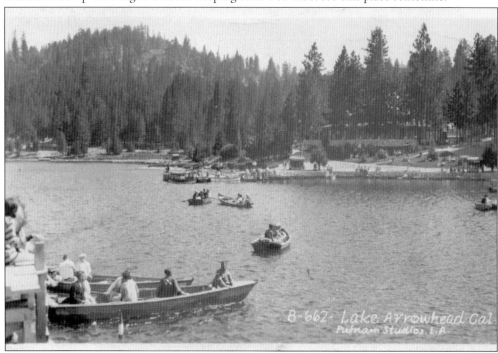

B-662- Lake Arrowhead Cal.
Putnam Studios, L.A.

Away From the City. British actor Leslie Sketchley sent this card to his mother in 1929. It reads, "I am having a wonderful time, it is such a change here from the city. . . . My hotel is just behind the dance hall in this picture. The company is paying $6.00 a day for my room. . . . Leslie." This card underscores just how different Lake Arrowhead is from the city.

LAKE ARROWHEAD, CAL.

AT THE VERY BEGINNING. This card, postmarked June 24, records the opening of the Arlington Lodge on June 23, 1923. It was sent to Manhattan Beach, California, and it reads, "Cap. John & S. R., We came up here on our 19th honeymoon. The place is not finished as yet but they are doing wonderful things. Big hotel opens tonight $10.00 per plate am sorry we have to leave before the feed, must be good at that price. Yours F & C." A $10 dinner in 1923 was a large amount of money to spend on a meal, and the honeymooners surely missed out on a sumptuous feast. The Arlington was the brainchild of A. L. Richmond. Unfortunately, he was something of a dreamer and appears to have overextended himself, resulting in financial ruin, which was also caused by the Depression. The Arlington was renamed the Arrowhead Lodge and is now the site of the present Lake Arrowhead resort hotel.

FROM CAMP FLEMING. A dutiful son writes in 1923, "Dear Mother, We spent the day in walking mountain trails. . . . We went on a ridge of a mountain and had the most marvellous view I have ever seen. Wish you were here with us. You would see the most wonderful trees in the world." Impressionable as this young man may have been, this is not a bad recommendation at all.

THROUGH THE PINES. This card, postmarked 1928, reads, "We are having a lovely time. We had a row-boat all day yesterday, and as a result I have 8 blisters. This afternoon we had an outboard motor. The Lake is beautiful." The mention of blisters serves as a reminder that even the best vacations can have surprises. (PS.)

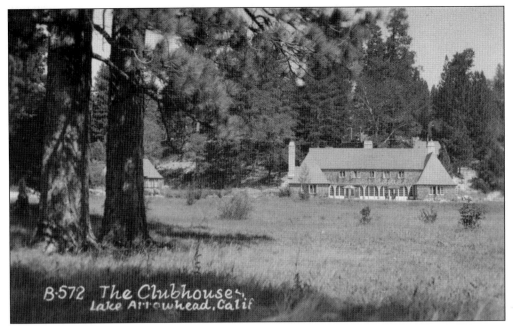

THE CLUBHOUSE, LAKE ARROWHEAD. This card, dated August 23, 1927, was sent by a niece to an aunt in Hollywood, California. It reads, "Dear Aunt Nell, We just came over to the village in the put-put. This is surely a beautiful place. Our fishing was not very successful yesterday. We played tennis in the afternoon at the Clubhouse, only it is now called Northshore Tavern. Love Helen."

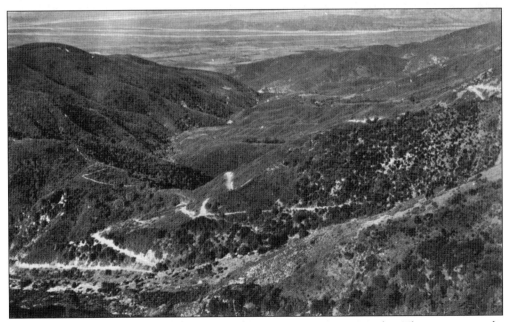

HILLTOP VIEW. This card was sent in 1918 to a Mrs. W. in Los Angeles. The message reads, "This is part of the road we came on. This is the most beautiful view. We have many trees and ferns up here. It is almost like the Canadian Rockies. . . . I hope you are well by now and that your bones are all rested. Maud."

SCOTT'S DOG TEAM, LAKE ARROWHEAD. Sent to a friend in Massachusetts in 1932, this card reads, "Snow up here but roses in our garden. It is gorgeous. Look up the bus fares, lines, etc. Boston to Los Angeles and write me your vacation time. Mr. C." The writer, a visitor to Lake Arrowhead, lived in Long Beach, and the roses are clearly in his garden there.

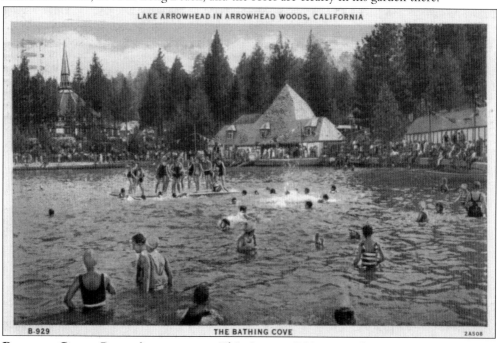

BATHING COVE, LAKE ARROWHEAD. This August 1938 postcard was sent to an attorney at a Los Angeles address. The back reads, "Hello: Swell air, Swell people, Swell time, Swell, Sure swell, How is your swell underwear? Adam." Whether this was sent by a teenager or by a colleague is unknown, but it shows the popularity of the word "swell" in the 1930s. (PS.)

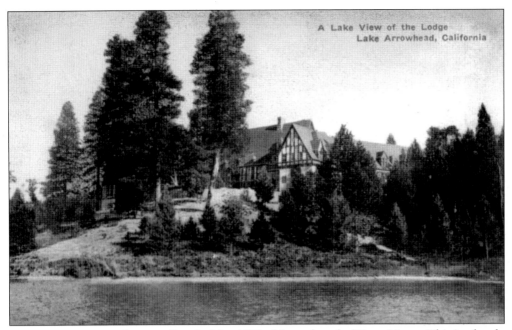

LAKE VIEW OF THE LODGE. Sent in May 1936, this card reads, "Dear Myra—This is a lovely place. It is now 6:30 a.m. and I am drifting in the canoe writing cards. The sun is glorious and the air clear. I don't know where the time goes to. Love, Mildred." (TAC.)

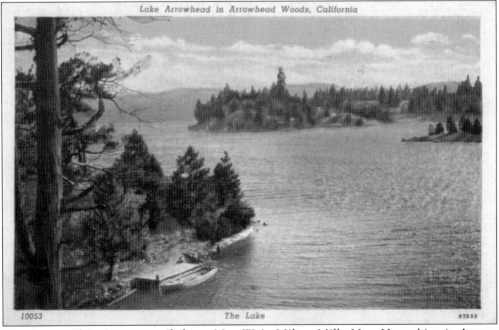

THE LAKE. This view was mailed to a Mrs. W. in Milton Milk, New Hampshire, in August 1926. It reads, "It is grand here in the mountains. Dick is building a porch of rustic logs—looks very nice. Annual carnival at the lake today—boat races, etc. Your letter came here yesterday." Clearly the writer of this card must have owned a rustic cabin in Lake Arrowhead. (CC.)

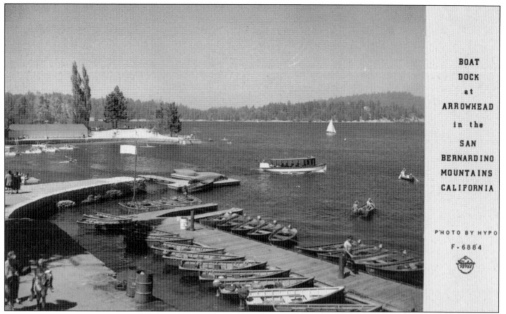

EXCURSION BOAT LEAVING THE DOCK. This card was sent to Ruth in South Gate, California, in 1950. The card reads, "God! I don't know what's wrong with me but I'm having an 'H' of a time writing. Please 'scuse. I wish you were here to liven up the party. One of these boats would sure be nice to have especially with a man, too." (FI.)

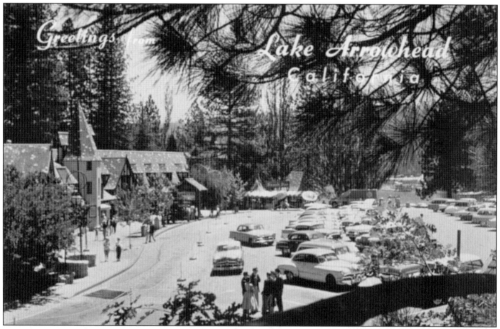

GREETINGS FROM LAKE ARROWHEAD, CALIFORNIA. Postmarked 1958, this card reads, "Dearest Mom & Dad, The sky is blue, the sun is shining. It is a gorgeous day. The air is real crisp. We are all going to church tomorrow. Don't think we'll do too much work this week-end. Love Ruth & Ed." Lake Arrowhead has always been a great place to get away from work. (WRP.)

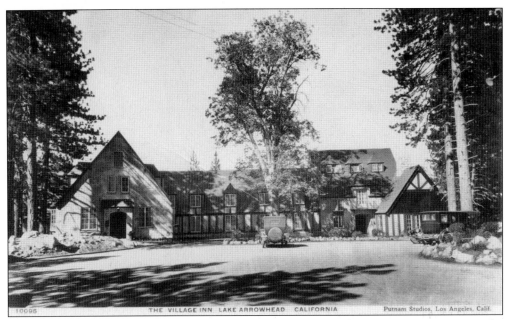

THE VILLAGE INN, LAKE ARROWHEAD. The author writes, "This is a summer resort near the lake. Some of the rich people of L.A. have beautiful cottages here. Others stay at the Inn. It is a wonderful resort after you get up here." Note the oblique reference to the actual trip up the hill being less than wonderful before the High Gear Road was built. (PS.)

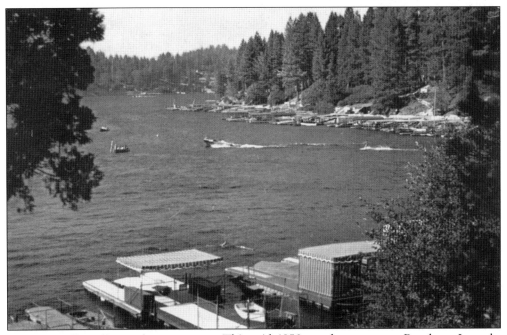

ORCHARD BAY, LAKE ARROWHEAD. This mid-1950s card was sent to Pasadena. It reads, "Dear Janet—This is the life! Nothing to do but eat, sleep, and play bridge! A lazy life! Beautiful view of lake from our front porch. Windy and cool. Gertrude has been with us, but is leaving this afternoon. Love Helen Louise." What an advertisement. (CC.)

119

"THIS IS THE LIFE." Sent to a Mr. and Mrs. H. of Alhambra in 1953, this card's sender wrote, "Hello Folks, This is the life for us here among the beautiful trees & wild life. Lois is taking pictures and I trot along. Wish you were here too. Cora." This type of card was in use from the mid-1930s to the mid-1950s. (DC.)

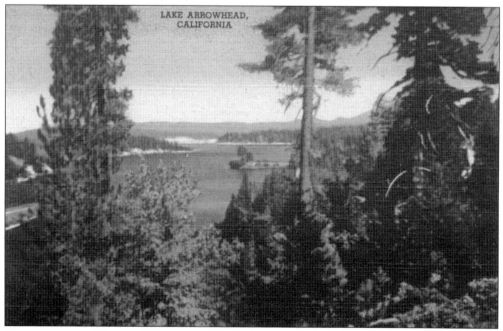

THROUGH THE TREES. This postcard image was mailed on July 4, 1939, to an address in Pasadena. The message reads, "Dear Sister Sidney, This spot is just as delightful as ever. We have a nicer place than last time which also has a beautiful Cris Craft boat. Expect you to come up. I will be home Wednesday. Wilbur." (CC.)

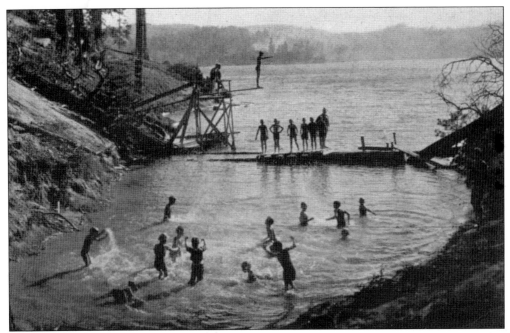

ROBINHOOD BAY. The back of this 1920s card reads, "Dear Mary, Am having a very nice time. Wish you could have come along. This is the most beautiful spot in California. Sincerely, Jessie." This writer was clearly impressed with Lake Arrowhead. Calling it "the Most Beautiful Spot in California" is hard to beat.

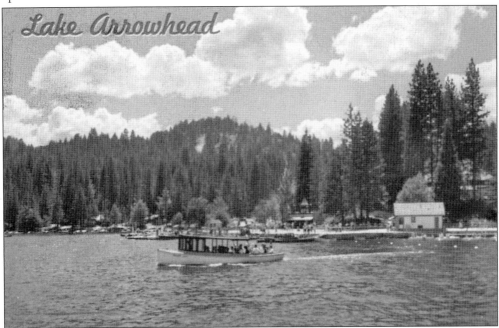

A FERRY EXCURSION. This card was sent in September 1959. It reads, "Hello City girls— Arrived yesterday at this magnificent place. The view of the Lake from the Lodge is a beautiful sight to behold. Am enjoying the tranquility here—nothing to do but relax, read and breathe in the fresh air. Love Darlene." (WRP.)

VILLAGE INN POOL. Sent to parents in 1968, this card reads, "Hello Folks, We are spending our vacation here. We bought a beautiful lot, looks very much like we will retire here. The weather is perfect, never smog or fog or heat. We have a lot that is practically facing a lake & golf course and has many other features. Hope you & family are fine." (JGC.)

THE UCLA CONFERENCE CENTER. This card was sent in February 1960 to a Miss S. in Malden, Massachusetts. An aunt writes, "Hi Mary, Having a wonderful time. Just came back from seeing the movie star's homes. Beautiful! I got Broderick Crawford's signature. Been on the go every minute. Living like a queen. Take care—love to all. Auntie Shirley." (DPI.)

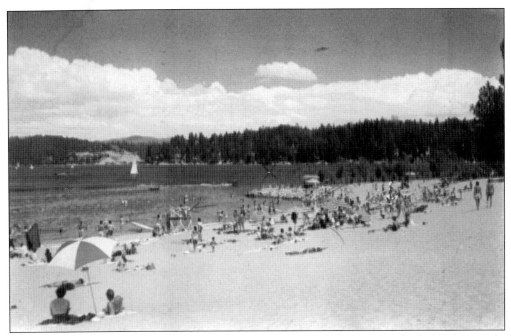

BEACH AT LAKE ARROWHEAD. This card was sent to Buffalo, New York, in 1956. It reads, "Hi Troops! Said I'd send you a card, so here it is. I'm on the beach now while Ron lifeguards. Tons of kids up here, and it's just fabulous. Hate to leave. See ya! Love Sandy." (RP.)

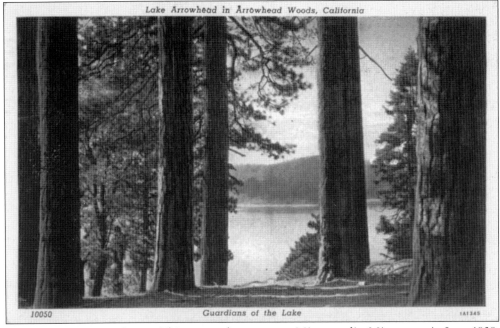

Lake Arrowhead in Arrowhead Woods, California

10050 Guardians of the Lake 1A1345

GUARDIANS OF THE LAKE. This postcard was sent to Minneapolis, Minnesota, in June 1939. The message states, "A mile high they say and beautiful beyond compare. The Brownridges & we spent the weekend in this gorgeous place and only regret it's time to go back to L.A. Maude." (CC.)

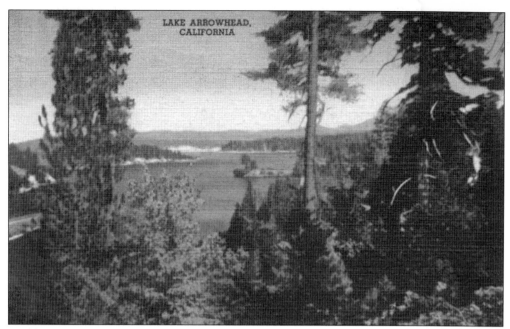

SIX GIRLS AT THE LAKE. Sent in 1948 to Hollywood, California, this card reads, "Hi! We're having a beautiful blizzard right now up here at Arrowhead. We six girls are really having a super time this vacation week—We've been tobogganing on dish pans down the hills. What fun!!! Lots of love, Carol." (CC.)

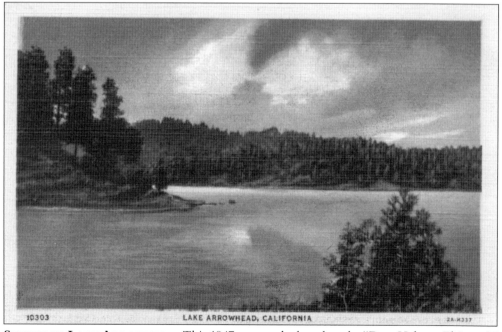

SUNSET AT LAKE ARROWHEAD. This 1947 postmarked card reads, "Dear Helen—Elsie and I drove the Ford down to the Lake to pick up Lillian and Sheila who hiked down the canyon trail this afternoon. They were glad of a ride home. Many people vacationing at Arrowhead. Our rambler roses are in bloom. Weather perfect. Wish you were here. Love, Florence." (CC.)

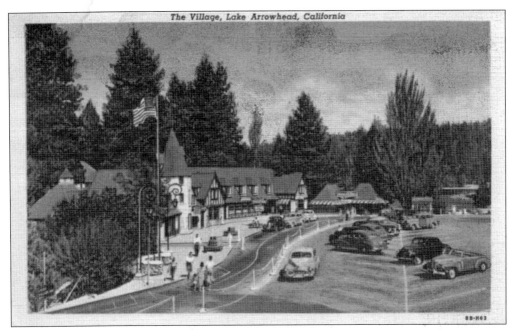

The Village, Lake Arrowhead, California

THE VILLAGE, LAKE ARROWHEAD. This linen card was sent to an aunt in Sault Ste. Marie, Michigan, in June 1959. The postcard sender wrote, "Dear Aunt S, We, some girlfriends and I, are spending a week up here. We are really having one perfect time. The lake is wonderful & we're all getting tan!! Love, D." (CC.)

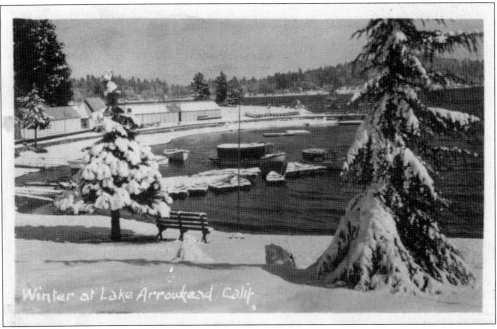

Winter at Lake Arrowhead Calif

WINTER AT LAKE ARROWHEAD. This card was sent in February 1935 to Pennsylvania. It reads, "J & Hetty, Joe & Marian are here & having a snow ball match. I wish you were here, I would wash your face with snow. As ever. Love, Dad."

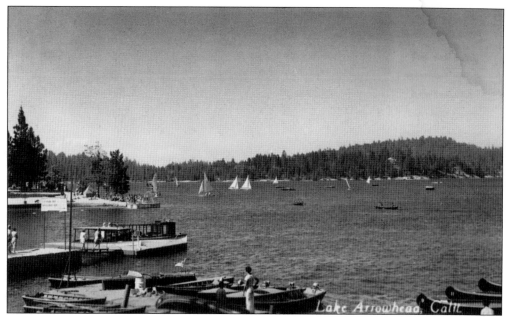

MORE BOATING ON LAKE ARROWHEAD. Postmarked 1943, this card reads, "What a time we are having! The weather is wonderful. Lake is beautiful & I wish I didn't ever have to go home. Will be starting back Wed. morn. and will call you soon after. Love Beryl." This writer is just one of many expressing the desire to "never go home" after visiting Lake Arrowhead.

TOO BUSY TO CALL. People have always been in a hurry to get to Lake Arrowhead. This card, sent in 1928 to Los Angeles, reads, "Dear Pearl, Thank you so much for your sweet note. I expected to call you before we left, but just was too busy. . . . We are having a wonderful vacation up here. My Love to you all. Olga."

SELECT BIBLIOGRAPHY

Beattie, George and Helen. *Heritage of the Valley*. Oakland, California: Biobooks, 1951.

Garrett, Lewis. "Postal History of San Bernardino County." *San Bernardino County Museum Quarterly* Volume 39, No. 4, Fall 1992.

LaFuze, Pauliena. *Saga of the San Bernardinos* (two volumes). San Bernardino County Museum: 1971.

Mountain News and *Crestline-Courier News*. Newspaper columns, "Mountain Mileposts." 1993 to present.

Rider, Fremont. *Rider's California*. New York: The Macmillan Company, 1925.

Robinson, John W. *The San Bernardinos*. Arcadia, CA: Santa Anita Historical Society, 1989.

ACROSS AMERICA, PEOPLE ARE DISCOVERING SOMETHING WONDERFUL. *THEIR HERITAGE.*

Arcadia Publishing is the leading local history publisher in the United States. With more than 3,000 titles in print and hundreds of new titles released every year, Arcadia has extensive specialized experience chronicling the history of communities and celebrating America's hidden stories, bringing to life the people, places, and events from the past. To discover the history of other communities across the nation, please visit:

www.arcadiapublishing.com

Customized search tools allow you to find regional history books about the town where you grew up, the cities where your friends and family live, the town where your parents met, or even that retirement spot you've been dreaming about.